Journeyartfully:
Secrets for Living
an *Artful* Life

Pattie Ann Hale

Journeyartfully:

**Secrets for Living
an *Artful* Life**

Dedication:
This book about artful living
is dedicated to my children: Cory,
Timara and Timicia. You are the most
wonderful children ever. You each are
creative and unique in your own
special way. You all have
taught me so much about
being artful as I have
taught you. We share
a language
of love
and
art

.

Journeyartfully -
Secrets for Living
an Artful Life

Author: Pattie Ann Hale
www.PattieAnnHale.com

Pattie Ann Hale
Copyright © 2014 Pattie Ann Hale

ISBN: 1496105532
ISBN-13: 978-1496105530

CONTENTS

Journeyartfully:

Secrets for Living

an *Artful* Life

Pattie Ann Hale

ENDORSEMENTS

From Ray Hughes....
"Page after page of prophetic glances that are sure to reshape your understanding of life.
Walk slow and pay attention, the truths in this book are beyond wonderful. I am not surprised by it as much as I am amazed. My journey just changed. Thank you Pattie."

Ray Hughes
Speaker and Musician
Founder, Selah Ministries
Author of *Sound of Heaven, Symphony of Earth*
www.selahministries.com

From Vivien Hibbert....
"Pattie Ann – I am so proud of you for writing this book. It is a pleasure to read and a total inspiration. You have touched every level of our creativity: body, soul and spirit. I am deeply moved by your words. Thank you. There is so much healing in these pages.

All creatives should read this book with a highlighter pen in hand, time to linger as his or her heart is flooded with inspiration, and a hungry spirit ready to embrace the Divine Creator. It is He who sings on

every page, awakens our dreams, and inspires noble plans. Without any trace of condemnation, Pattie Ann shakes us from our old and tired ways of thinking. She skillfully facilitates as we get in touch with our innate creativity and she shines a light on some essential pathways that we must all travel if we want to fully grow into whole and holy artists. I only have two questions as I finished this book: who would NOT want to live artfully after they've heard this message... and what would stop them from running to their craft with renewed passion and destiny?"

Vivien Hibbert
Author of *Prophetic Worship* and *Praise Him*
Founder of The Worship Arts Conservatory
www.vivienhibbert.com
www.theheartoftheworshiper.blogspot.com

From Pastor Darrell Harmon....

"It is an honor to recommend this book by Pattie Ann Hale. I have been blessed by her life and ministry and now I get to enjoy one of the most inspirational writings I have read in a while about the artist in all of us. Pattie will take you on a journey to see what lies within you. She will invite you to open your eyes to the artist in all of us because we are made in the image of the great Artist. She will encourage you to surrender to the journey and to step into something new and full of life, yet, to your

surprise, you will find you have been on a journey that will bring you back home."

Darrell Harmon
Senior Pastor, Interstate Fellowship
Author of Appalachian Visionary
www.appalachianvisionary.blogspot.com

From Pastor Sam Fine....

"If you don't see yourself as an artist already, this book will undoubtedly change your perspective and possibly your life. Pattie Ann Hale brings a fresh, clear, revelatory approach to discovering that we all are creative, made in the image of the Master Artisan. She skillfully guides you through the dormant places of one's heart, to ultimately arrive at a place of awakening and freedom. Buckle your seatbelt, this journey will propel you into a new dimension!"

Sam Fine
Senior Pastor, King of Glory Christian Church
www.kingofglorycc.com

From Matt Tommey....

"I've been walking in the woods for over twenty years now, receiving inspiration from the wonders of the natural environment and its Creator and responding through my own creative medium of sculptural basketry. My responsive dance with the

beauty of nature has drawn me ever closer to the Father of All Creation, the Great Designer as I learn to hear, feel, smell and know the nuances of His creation.

In her book, *Journeyartfully: Secrets for Living an Artful Life,* my friend and colleague in creativity, Pattie Ann Hale, removes the veil from this often misunderstood dance of creative living and brings you into her world of detail, wonder and whimsy. As a mother leads a child, she holds the reader's hand through the process of learning to live an artful life, bringing you into green pastures yet to be discovered. If you want to learn to live life as our Creator God intended, read this book."

Matt Tommey
Founder/Executive Director, The Worship Studio
Author *Unlocking the Heart of the Artist* and *Creativity According to the Kingdom*
Sculptural Basketry Artist

From Stephen Roach....
"In Secrets for Living an Artful Life, Author Pattie Ann Hale writes as an artist *for* the artist within us all. Her gentle approach to creativity makes living artfully accessible for everyone."

Stephen Roach
Musician and Author
www.stephenroachmusic.com

FOREWORD
BY RAY HUGHES

I have had the great privilege in my life to travel to many countries. My wife and I enjoy museums, especially those that display the uniqueness and diversity of culture and art. Whether it be a small town museum in west Texas that celebrates the rodeo culture and its local heroes, or the world renown museums that you find in places like Paris, London, and St. Petersburg, Russia. I have strolled in wonder and stood in amazement and taken in the sheer genius of Monet and Rembrandt. I have also been in the presence of the world's largest stuffed prairie dog, and I have beheld a Jimi Hendrix guitar. I've looked through glass at the personal scribblings of the greatest Irish poets in history and I've spent a few solitary moments with Mona Lisa.

History speaks loud and clear that there is no shortage of geniuses in this world. Literary giants, musical genius, and unbridled imagination abounds. Whether it be the mastery of canvas that moves you

or the sheer passion of a lyric that touches you in the deepest part of your soul, we can all agree that our lives have been made richer by those considered to be creative geniuses. They are those who have stood out from the rest and set the tones and tempo for us all to gasp in wonder. They are the ones who were able to marry genius to generosity and they gave us the results of their unique journeys. They are the ones who so inspire us that we not only choose to remember, but we must remember. History has proven them to be unforgettable because they gave us their expressed experiences of life through their art. They painted and danced and sculpted their way into all of our lives and left us with this challenge and charge: "Live your songs in such a way that your memories become melodies and your melodies become memorable."

So, whatever art form you have chosen to express your journey, remember this: Music doesn't just touch your senses, stimulate thought and awaken memories. Dance doesn't just engage your physical body in movement and self-expression. Art doesn't just bring color and texture and image to canvas. Writing and storytelling are not just literary and verbal communication mechanisms designed to convey thought and emotions and dispense information. These are not just forms of creativity and personal expression either. The ways of an artful life are gifts that help our human-ness and our true heaven-ness find one another. They awaken us to life

and cause our heart, imagination, wonder, beauty, mystery, sadness, pain and joy to find one another and dance the most elegant steps of life.

As Pattie so beautifully states in a sentence in this book: "The world is waiting for you, not another version of another." So live your authentic life, create your authentic art, find joy in your journey, give your all, and be outrageously generous.

Ray Hughes

Speaker and Musician
Founder, Selah Ministries
Author of Sound of Heaven, Symphony of Earth
www.selahministries.com

1

EMBRACING THE
CREATIVE JOURNEY

Albert Einstein said, "Imagination is more important than knowledge. For knowledge is limited to all we now know and understand, while imagination embraces the entire world, and all there ever will be to know and understand." Living an artful life is an expansive way to embrace all that can be. Artfulness is living rich with treasures untold. I want to invite you to live an artful life - one that is rich and full of beauty, depth and meaning.

Though we would not readily state it, many of us are afraid of living a truly beautiful and awesome life. It's easy to live a normal life full of regular struggles. It's painfully easy to live a life without creativity. It takes courage to find a unique path. It is a higher way of living and the truth is that down deep in the core of our being, we long for it. Living a life above

the mundane will call you out to be separate. In this way of living you will find strength, identity, and the difference between you and others. You will find that you have a very unique purpose for being. With that knowledge will come responsibility to live in a way that reflects that wisdom to others in quiet ways and in ways that are out loud and open. This takes courage. Exploring creativity will take you into uncharted territory - into directions you may be afraid of, where others do not approve of you, and where you are thought to be flighty, disillusioned, and a dreamer. Are you ready for that adventure?

Why Live Artfully?

I'm not here to convince you through my words that you should live a life that is artful. I'm not writing to give you prescriptions or formulas, rather I hope to grab hold of that part of you that is alive inside that is even now quivering for blooming. I believe you are ready for the awakening. There is power in simply agreeing to go after the thing you have desired, but never had. So if you are reading this book, I am assuming that you want to know the secrets to live an artful life. Congratulations for saying yes to the beautiful journey!

The greatest secret is that it is really not a secret. You already know how to be artful. Creativity is an innate gift which has been given to us all. We simply must place our intention on focusing on the creativity that

lies within us. Perhaps my words will turn up the knowing in you like turning up rich soil for planting. You have within you all that you need to live an artful life. The Creator has put an ever increasing capacity within your soul, mind, and body to understand the adventure that awaits you. You could actually go after it your whole lifetime and still there would be more to grasp.

Within the acorn lies the complete understanding of the fully matured oak tree. The small rose bud fully matures naturally into its glorious beauty. You have within your own innate understanding a knowing of how to be creative. You are created in the image of God. We hear that and pass right through it. Slow down and think about this. The very wisdom, goodness, love, and creative power of the Creator is what you are made of. This is your natural intelligence. So the question is, why are we so dumb? If we are not tapping in to our innate creativity, we are blindly looking to some type of false intelligence.

Our Ideas About Creativity

So often in our culture, we think of artfulness as a way of doing things that are artsy. We think of creativity and art as something we do rather than a state of being. We also think of art as an occupation and the financial success of that occupation either makes us a real artist or not. I want to propose something other than that stream of superficial

thought. A true artist has little to do with how skillful you are, how financially successful you are, or how many accolades you have achieved. Being an artist is about being. I am creative because I am created in the image of God. I am a daughter of God because He is my Father. I am an artist because I am. It's that simple. We are all artists because we are made in the image of The Artist.

Everyone is an Artist

The problem with our artistic understanding is that we narrowly define art. We narrowly define creativity. Without presenting to you the exhausted definitions that are out there about art and creativity, because there are many and a new one is forming everyday, I would like for you to think about art as a core way of being. I want you to, by faith, believe that every one is an artist, especially you. This takes surrendering your analytical thoughts, judgements, opinions, your ideas about performance by you or others, your striving about professional achievements or spiritual eliteness, your worries or pride about artful skill, and even your wounded creative places in order to make your mind available to grasp the very real concept that you are made in the image of The Great Artist. Do you believe?

Creativity is actually about surrendering. The potential for creative brilliance is already in you. The key is removing your conditioning about art and

being again like a little child ready to experience wonder. Your mind and spirit must be open. The scriptures tell us that we should become like children in order to enter into the kingdom. (Matthew 19:14) The kingdom of God is creative. It is actually full and vibrating with creativity. The Creator created the kingdom, so of course the kingdom is creative! The Creator created you, so of course you are creative as well! The key is learning to surrender to the creative flow that continually courses through your very being. It is your choice. You have the free will to choose creativity or not.

Little children usually do not have a difficult time grasping truth. They know that they do not know, so they come with teachable spirits. We have to give up the idea that we know what creativity looks like. We must give up our preconceived ideas about it. Especially when we look at the way we have always created, we must be open to new ways. To live an artful life, we must continually surrender to the fact that we do not know. This turns all of life into a mystery and an adventure. Holy Spirit knows all things and will bring them to our remembrance. (John 14:26) We can trust God to bring to our remembrance the innate artful essence that he placed in us. Earnest Hemingway taught that in order to step into the creative zone and make a great artistic work we should simply begin by writing one true sentence. If you can write one true sentence or say one true thing, say: "I am an artist!"

Creativity Brings Us Close to God

Within all of us is the longing for the spiritual. No matter what we believe about God, we long for the divine. Our souls were made to cry out for enlightenment. Creativity brings us close to God and close to the wholeness we crave. As we embark on creative journeys, God meets us there. He will show us the way if we will stop going the way that doesn't work and simply stand still and wait for creative instruction. We must let the process be what it needs to be for the *now* moment. This is the very nature of creativity - to wait for the mystery and then step into the place of spontaneity when it comes. God is mystery and to surrender to the creative process involves stretching out our limbs to find him. We may do this through a dance, where our literal fingers press into the rhythms in the atmosphere. We may paint the colors that only our spirits can see. We may catch words coursing through our minds and bring them into poetry or prose, or act out the bizarre scenes of dreams. Again, coming close to God is found in surrendering - simply letting the mystery unfold.

Something More

Do you find yourself going through the rote movements of everyday life feeling as though there is something more? Even as artists, we can find our lives being very mundane, even boring. Who wants

that? Not God. He wants so much more for us. His very extravagant nature can be experienced in every moment. He has put within us the desire to experience life like that - it's our natural bent - our natural intelligence. I don't intend to be presumptuous. If you have trouble believing this, I encourage you even more to press into creativity and artful living. I've found that in that intentionality, God shows up literally in every moment. His nature is found there in the spaces between the everyday moments. A rich meaningful life can be found and kept through artful living. See, this is not really about creativity for creativity's sake. This is about living an abundant life, a joyful life, a satisfied and actualized life.

The actualized life is when we are living the dream God has dreamed in us. It is living life at our fullest potential, using our talents and God-given gifts to be all we are created to be. Actuality is when the truth comes into the now moment and makes itself known. When we agree with God that we want the authentic purpose of our life to make itself known, it will. It is about agreeing and surrendering to the unfolding process of abundance. Living artfully, giving ourselves to a creative way of living, can show us the way to our destiny and cause us to love the journey. Life itself holds the elements of our spirituality. There is such a satisfaction in seeing God in everything. When we embrace life in this way, every moment becomes energized with creativity. It

7

keeps us on the edge of the next creative happening which is essentially nudging us ever so mysteriously into our next instance of actualization.

Religious Answers

Is there something more? How can our lives be more meaningful? As we ask these questions, we often find that creative answers are not found in religion or in the church. Sadly, within the Christian church, our answers usually come in the form of boxes that have been formed by tradition, legalism and a tight structure of religiousity. Trite answers are given that are intended to be the fix-all for our yearnings but so often leave us feeling like there is still something missing. The artful life can actually be frowned upon in our Christian circles. If we believe in being present, learning from the moment, then we are accused of not trusting in religious creeds. If we focus too much on nature, we are accused of being pantheistic. If we value the soulfulness of our journey, we are thought of as not being spiritual and being abased in some way. Being present, learning from nature and living a soulful life are only a few of the elements of an artful life which do not fit nicely in our Christian boxes.

There is a void in most Christian circles that begs for creativity. What would it look like if our typical devotionals were replaced with a nature walk and a simple conversation with God? What if we were to

approach the scriptures in such a way that we sang them or envisioned them as a painting or a drama? What if in prayer, we spoke visually to the Lord with color and line and form rather than words? Why is our modern worship and praise not full of dance? Many of the Hebrew and Greek words we use for worship and praise actually involve movement. Yet, we sit still in *reverence* for the sake of order. What might a joyful noise to the Lord sound like if we let it wail out of us in true exuberant praise rather than conforming it to the structures of the unwavering typical rhythms we hear over and over in mainstream Christian music? Is anyone else tired of this?

See, I believe God is so fathomless in his beauty that our expression of adoration to him should continually be fresh and new and ever-changing. God is always the same but we can always see a new facet of him if we will peer into his beauty. David said, "You said unto me, 'Seek my face... and I said Lord, I will seek your face." (Psalm 27:8) David's relationship with God was never boring because he was always seeking his face and finding a new beauty, a new word, or color, or harmony that he had not previously known. We have made a market of our Christianity with nice products that have actually become idols to us and all the while, we push out new expressions in the name of righteousness. This is an example of righteousness as filthy rags. It is the selfish ambition of a whole corporate mass to control and manipulate the system so that goals and

projects and lowly debased kingdoms are exalted. I believe Creator is sick about it. He is calling us all back to his nature, the nature of himself, the nature of Creator.

Coming Home

A life in the arts draws one closer to the spiritual path. The very nature of creativity provokes the soul to long for the mystery. The way creativity invites one to search for the next glimpse of inspiration awakens the soul to ponder the higher realities of the Spirit. Colossians 1:27 tells us that the Great Mystery is that Christ is in us and that he is the hope of glory. Many artists are seeking spiritual paths because they find the tangible movement in the spirit when they open up to the creative process. Whether they find Christ on the journey is really a personal issue with each individual, but I do believe that if they are seeking, he will find them. Creativity is a divine open road full of signs, resting places, and speeding zones where a traveler can find his way home to the Creator. It's all about coming home.

Our Personal Culture

Spirituality is always rooted in culture. We must ask ourselves about our own personal culture. Do we value the creative journey? Are we actively seeking the path to God or do we simply live by the religious rules to which we've been accustomed? To truly

embrace an artful life may go against the grain of conformed organized religion and structured systems. The path to God is very personal. When we can learn to walk our personal paths through the unique creative ways God ordains for us, our paths will merge and the collective will be organically and powerfully beautiful. The variation will more likely resemble the trueness of God because as we come together, each one shining in our own beautiful knowledge of him, we will reflect the radiance of the many-faceted One. Imagine a stain-glass cathedral window where all the pieces were the same color. Boring. How much more the stain-glass resembles the glory of God when it highlights and shines forth with a myriad of color and shapes and depths. This is a picture of the Kingdom. It begins with us developing our personal culture of devotion to God.

As we move through life, may we live it to its fullest by embracing the creative journey. The reward of creative living will show up continually as we see the divine nature in the entirety of our lives. Conversations will be symbolic messages that connect us soul-to-soul and spirit-to-spirit. Listening to music will be an extension of listening to the heartbeat of the world and of heaven. Living with those we love will be a compassionate dance of give and take. Our normal way of life: bathing, dressing, cooking, working, making art, singing, eating, loving, and communicating, will become rich with

divine meaning as heaven invades earth. Artful living opens up the portal of the divine experience. "On earth as it is in heaven" is our loftiest prayer and our greatest reward.

2

CURIOSITY

Walt Disney said, "We keep moving forward, opening new doors, and doing new things, because we're curious and curiosity keeps leading us down new paths." The curiosity of children is a beautiful thing. One day I sat by the cutest little six-year old named Ruby at a restaurant during a birthday party for a friend. The grown up party did not really interest her because she was totally lost in playtime with the salt and pepper shakers. They had become her dolls. It made me think of my youngest daughter who always played like that when she was around that age. I was intrigued by her imaginative play. I found myself disengaging from the grown-up conversations around me so that I could perhaps enter her world of play. I asked her a couple of questions of which she was not interested in answering. I was still the adult on the outside of her

curiosity. I realized that in order to enter her fantastical world, I had to become imaginative like her.

I asked her if she had been swimming under the ocean yet. She looked at me quite surprised and puzzled. I pointed under the table and said, "Under there, have you been swimming down there in the ocean yet?" She looked at me with disbelief, then her little freckled face lit up and she realized I was introducing a new story. She was curious and her face beamed with excitement. Before I could fully take joy in her expression, under the table she dived. I heard giggles under the table as she swam around and as I insincerely apologized to her father, with a gleeful smile, of course. I loved that she was curious and courageous enough to take the dive. A minute later, she emerged back to her seat, eyes wild with excitement and mind full of words she had to express about her undersea adventure. I loved our fantastical conversation that went on and on for the rest of the time at the table. I looked into her eyes and recognized the same curious joy that I saw in my own daughter not too many years ago and the same joy I remember from my own six-year-old times of swimming in the oceans of hardwood floors. What a gift - curiosity.

We Came Here to Play

The element of curiosity is extremely important to living a creative life. It is the very play-like energy of

creativity. Even though it has somewhat of a goal in mind - the desire to know and understand something that we don't know - it remains totally free to spontaneously uncover whatever may be found. It is naive in its intention, yet serious in its pursuits.

Curiosity is the seed of innovation. Do you want to create something? Get curious and soon the creativity will start to flow and you will have innovative ideas. Curiosity spawns more curiosity. Questions birth questions. The path of curiosity leads us from a general pondering to the hoped-for quality of asking great questions. Most revelation is found because of hopeful pondering. As the scriptures state, "It is the glory of God to hide a matter and the glory of kings to search it out." (Proverbs 25:2) God loves for us to search for his ways, paths, and wisdom. There is no fix for curiosity. Once it begins, the path is continuously unfolding. It keeps us on a joyful adventure. Curiosity, by its very nature, is expansive - ever-increasingly larger than our finite moments of focus.

When my son was a small child, he had enough curiosity for the both of us. He was always taking things apart to find out how they were made and what made them work. I remember his favorite toy as a baby was putting the shape blocks into the box. He still loves to know how things work! He is always tearing things apart to see what the inside looks like. As the years have went by, it has moved from

digitized toy trucks to things like laptops and gaming systems. Curiosity can be expensive! As a child, Cory would always ask me to delve happily into curiosity with him. Since he was my first child, I was his play-buddy so I had to oblige him in his curiosity. He was always making up a new game. It was great fun for me. There was never a boring day with him.

One of his favorite things was for me to make up stories for him while we were in the car. I would allow him to get involved by asking him to pick out a few random things for our story. We would drive along and he would pick out things like the dog he saw in the neighbor's yard, a stop sign, a fire-truck and a tree. I would then jump in and make a fantastical silly story about the random objects, letting him join in to help me when his little curiosity grew so big he could not contain his thoughts. His imagination was expanding. We were developing creative bonds and his love for story was growing. He still, as an adult, is always telling me the oddest bits of information. He is still curious and loves a great story.

Recently, I came across a Youtube video of Mr. Rogers from the PBS series, *Mr. Roger's Neighborhood* which I watched almost everyday when I was a child. Fred Rogers was a major part of my daily life and the lives of other children during the 70's. He actually encouraged children for more than thirty years to be unique, curious and kind. So when I

recently saw the remix produced by PBS Digital Studios in conjunction with John D. Boswell, it awakened something in me that I had not acknowledged before. In the video Mr. Rogers is singing, "It's good to be curious about many things..." Mr. Rogers' voice speaking encouraging things is mixed with scenes of curiosity from the vintage show. I found myself in tears as I watched it. I know, sappy, right? But I was so moved by this video. Why? See, I'm even curious about curiosity!

I remembered myself at about the age of four sitting in my living room with my huge black trash bag of junk poured out all around me, creating little dolls and clothing and purses out of scraps of fabric and buttons and paper. I would sit for hours sewing with a needle and thread and cutting fabrics and finding treasures in my huge pile of what I would call now, mixed-media materials. I would paint and sculpt play-dough and sing. My mother was wonderful to let me explore that and I remember that she would even show me how to make things when I couldn't figure it out by myself.

The thing that moved me about the video so much was that I also remembered how my dad, who didn't have a love for creativity like my mom did, would come in from work and grumble and complain about the mess on the floor and demand that I clean it all up. Play time was over. Curiosity time was done. So, when I saw this video and the memories came

flooding back, I suddenly realized how much Fred Rogers had spoken into my life and had actually given me a sense of salvation every day as I created with his encouragement and affirmation. He taught me that it was good to be curious, even when everyday at 4:00, I was made to feel that I was not good for being curious. I thank God for Mr. Fred Rogers and his message.

Kevin Morrison, COO of the Fred Rogers Company, commented on the video, saying, "I think that the thing we like about the piece most of all is how it shows that Fred was really ahead of his time. The message that it's good to be curious, to use your imagination, and that ideas are the 'garden produce' of a fertile mind was something he stressed through-out his career." Fred Rogers, a Presbyterian minister, was an integral part of developing creative minds. He taught us that we could do anything if we simply put our minds to it. The key is putting your mind to it. Decide to be curious.

Experiencing the Unknown

Curiosity provokes us to uncover the unknown. To look at a new canvas and embark on turning it into a painting can be quite daunting. It can even be stressful. To stare at a blank page and expect to write a poem or a story can be frustrating. Curiosity frees us from that. If we approach the creative process

with the wonder of curiosity, and are able to stay connected to that sense of wonder, then joy awaits us every time. The sheer naivety is a thrill. We make art too complicated. It's as simple as playing. Playing starts with curiosity. To bring into existence the solution to what was previously unknown is our God-given talent. We all have it. Jeremiah 33:3 says, "Call unto me and I will show you great and mighty things which you do not know." God loves for us to be curious. He loves our playful questioning in the process of our creativity. Never underestimate that.

The element of play in art is the work of the masters. Wassily Kandinsky's spontaneous paintings sing with color and form because he knew how to play. His curiosity helped him to create works of art that were guided by the Spirit and explosive in their very nature. His paintings are purposefully child-like. They capture the wonder. He was very intentional about playing. He said, "In art there are no rules because art is free." Jackson Pollock, the famous action painter who dripped paint onto large canvases in a dance-like method, respected how the process of curiosity kept the painting moving until it became what it needed to be. He said, "Abstract painting is abstract. It confronts you. There was a reviewer a while back who wrote that my pictures didn't have any beginning or any end. He didn't mean it as a compliment, but it was." Pollock also said, "Sometimes I lose a painting. But I have no fear of

changes, of destroying the image, because a painting has a life of its own. I kind of let it live."

Divine Alignment

Curiosity is the innate craving to know the divine. The very nature of wanting to know more, to know how things work, to know the nature of a certain thing is actually our longing to know God. Our hearts long to uncover the mystery. God loves the chase. Because God has placed in us the desire to know, he has also provided the place of revelation - the satisfaction of knowing him. Through his gift of curiosity, he brings us into divine alignment with himself. When he breathes a breath across our atmosphere and our curiosity is aroused and we begin to search out the mystery, he is pleased. He loves this interaction with us. Isn't he a beautiful God to pull us into his flow like that? Continually being pulled into his flow, looking and feeling around for the next uptake into his perfect alignment is the joy of an artful life. Chasing the curiosity until it is found gives you a sense that you are actually the one that has been found. We can't help but make art out of that place. It births expression. It is a life-giving happening that requires a creative response. To see the mystery of yourself in your painting or hear your authentic heart in your song or poem is an awesome experience of knowing you belong and have been seen by the Divine One.

Curiosity Births Intuition

When you trust your intuition in the creative process you don't need to know why you are doing this or that, you simply do it. You simply trust the inner voice in you. If there is a phrase that articulates intuition it would sound something like, "I know this is the right thing to do in this given moment." Sometimes in Christian circles, intuition can be misunderstood and thought to be a way of moving within some magic force that we should not be delving into or that it is all about self-will. I believe responding to your intuition is actually tapping you in very closely to the Holy Spirit. Christ is in me. I am in Him.

The scriptures tell me it is in Christ that I live and move and have my very being, therefore, when I choose a certain color to use on a canvas with a deep knowing that it is the right color for that moment, then I am actually moving in the Spirit. When a dancer feels the push and pull of the rhythm and responds to that feeling with her actual movements, she is following the dance God has breathed into that atmosphere. When a writer suddenly knows the perfect stream of words or a musician flows into the perfect chord progression, this is God's gift of intuition being utilized. For the believer who is full of the Spirit of God, intuition is actually knowing and having confidence in the way of the Spirit. We

are called to walk in the Spirit, pray in the Spirit, move in the Spirit. Why do we block ourselves from believing that we can paint, dance, sing, write, and even perform in the Spirit? It's nonsense to not believe that intuition will move us along a spiritual path with God. Intuition is our God-given gift to know his ways. We can trust it. Without it, what do we trust?

The immediacy of intuition causes us to be creative in the *now* moment. God is always in the present and he wants us to embrace him that way. Reason kills intuition. Intellect is an important element of creativity but it must be partnered with intuition. Logic and reason will destroy creativity if it is allowed to rule. The creative process has many layers and cycles including times of free flow, spontaneity, focus, diligence, patience, use of skill, and times of being lost in the work. In my opinion and in my experience, intuition must be present in the entire process. Intuition is a definite knowing and a specific type of letting go all wrapped into one. Webster's defines intuition as the ability to understand something immediately, without the need for conscious reasoning. The way of the Spirit does not allow room for human reasoning. Reasoning is not wisdom. Most of the time it is a form of being critical - we call it critical thinking. Often reasoning about our creative process can lead to judgements, even harsh judgements which actually stop the flow of creativity and cause us to make work which has

no life in the process and no life in the finished product either.

The latin word for intuition is intueri, which means to look inward or to contemplate. Contemplation is different than analysis. Art created from the place of intuition carries within it the element of truth. God's truth lives inside us when we are abiding in Him. Where there is light, darkness cannot exist, so if we are in the light, then our intuitive gifting will be full of the light. We can trust that. When we are creating from sincere intuition, knowing that we are connected to the Source of Truth, we can trust that the recognition we feel in the intuitive moments is leading to the unfolding of the greater whole truth.

Intuition can only be received. It's not something we can order into place or something that can be contrived. It's a gift from the mind of God. It's like catching hold of something from the heavenly realm. The developmental stages of the creative process, curiosity, inspiration and imagination lead to intuitive response. God is speaking through the whole process, but the intuitive response of creativity is where we are called to action. We respond to the feeling of movement with further movement. We sing out the sound we hear in our spirit. We speak the words that immediately form in our mouths. Intuitive response establishes the will of God in the *now* moment. Jesus moved as he saw the

father move. He spoke what the Father said. He moved with divine intuition. We are anointed to do the same.

Receiving Intuition

Intuition can be received through four major ways: physical sensation and movement, through our emotions, mentally by the right side of the brain, and spiritually through discernment. Many of us are continually receiving these messages, however we are not in tune with the understanding. We can open our minds to the idea that God is always communicating - we simply need to listen, feel and know. Understanding how these receptions take place in our creativity is very much a personal journey, however, there are some generalities I can speak of.

Physical Sensation and Movement

Movement and physical sensation in our bodies are clues for expressing our creativity. Before I begin painting I will often worship through movement until I literally feel the tangible tingle of the Spirit on my arms, hands and fingertips. It's from that place of connection that I can paint in the Spirit. I instruct participants to do this in my prophetic painting workshops. I've done this with hundreds of people. Without fail, everyone who will enter into this type

of experience will physically feel the movement of the Spirit. Also without fail, when a person in a workshop will not enter into the experience of movement - stubbornly or insecurely holding back from moving, they stay frustrated the whole time and cannot seem to connect to the Spirit-led process. Holy Spirit is always moving, we simply must make it our intention to feel it. When we make a response, he gives more. Holy Spirit is tangible and he wants us to experience his touch tangibly.

The intuitive sense of movement can be utilized in all the artistic genres. Movement has rhythm. All the genres: visual art, dance, writing, drama, and music have rhythm. Movement is one of our core receptors for expression. Every toddler loves to dance. There's a reason for that. It's built into us in order to respond as human beings to the One who wants us to feel totally alive and connected to his heart.

Physical sensations in your body can also speak to you of the way of the Spirit. Tingles, visceral actions, taste and smell, seeing or hearing things highlighted in your natural eye and ear can be a reception of the message of God. Often while I am on nature walks, I will intentionally ask Papa to communicate with me as I take the journey. As my eyes take in the sights and my ears listen, it is as if there is a transference into the spiritual realm and colors begin to sing, sounds begin to inspire images. Natural things like pods and flowers become spheres of supernatural

healing. The smell of the morning dew becomes the message of God for me to have faith for a new day in my life. Leaves speak of passages. Living in such a way that we even invite our physical bodies to be alive to the Spirit is a vital key for living an artful life.

Emotions

Our emotions are another tool for intuition. We as Christians have been regretfully taught to not be led by our emotions. Though there is a balance to be practiced in weighing out the value and health of our emotions, I invite you to understand that they have been given to us by Creator for our benefit. Even negative emotions can be helpful if we will embrace them without fear. When we trust that God is omnipresent in every area of our being, we will not fear to take intuitive leading from our emotions. The visceral, creative responses we make even out of our most negative emotions can be a process of healing for our souls and a relevant message in the content of our art. Have you ever slapped color onto a canvas or danced crazily when you are angry? It's freeing! It's real. If we as Christians expect to be relevant to the world and just plainly honest with ourselves, we cannot continue to ignore the intuitive value of emotion in our work. It is a common tie that binds our human hearts together and furthermore, these are cords that bind us to the true expression of God.

Mental Intuition

Intuition can be received mentally in the form of words or phrases we see and hear in the *mind's eye*. When the mind of God communicates to our mind in creative ways, the communication is received by the right hemisphere of the brain. The right brain is the place where most creativity is processed, in contrast to the left side of the brain which is the analytical logical side. The right side of the brain is the curious side in which many studies have shown to be the place of spirituality. It takes practice in intuition to recognize when the right brain is receiving messages rather than the left brain thinking typical cognitive thoughts. Often when people are beginning to move intuitively, they will question whether the thoughts are their thoughts or if it is God speaking to them. This is reflective of the war between the left and right hemispheres of the mind. God's communication to us comes with a specific "knowing" which is actually the core sensation of intuition. Continual creative practice in intuition will refine the right brain.

God has not designed or destined us to be either right-brainers or left-brainers. God wants us to be whole in our minds with both sides actively utilized. However, when it comes to living an artful life, the awakened right side will lead us. Analysis usually kills intuition. Intuition should lead the creative process

and then the need for analysis will make itself known. When the time makes itself known for the left-brain to rule with analysis, we need to believe that God is working through that process as well. He is the God of spontaneity and freedom, however, he is also the God of order and structure which is the seedbed for analysis. When God enlightens the left-side of the brain the needful solutions found from analysis are no less divine than the processes of the right-brain. The conclusion of this is that both sides of the brain can be enlightened powerfully by God, however in the area of intuition, which is usually the starting point of creativity, the right-brain must be in charge.

Spiritual Discernment

The last point I would like to discuss about how intuition is received is through spiritual discernment. Discernment, in its basic definition, is obtaining spiritual direction and understanding from God. As we have mentioned, there are many ways to intuitively understand the divine leading. That sensibility is built into all of us. Discernment, however, is a heightened sense of intuitiveness. Discernment is a gift of God given to all of us, yet it does require a certain amount of refinement to continually utilize it in our lives. The same is true for utilizing it in our creativity and creative works. Discernment is a revelatory experience mixed with an unwavering

confidence that truth has come. It is a very distinct knowing that is more confident than simply sensing. When discernment comes to us, it is as if we have the exact direction and there usually is no question about its source or execution. Because of this level of knowing, it often comes with a sense of responsibility and calls for an immediate action that may not be as present with other forms of intuition. Discernment propels one into a place of authority. It is the highest level of intuition. It should be handled carefully as a direct word from God. Discernment must be accompanied with wisdom and should be submitted to the counsel of others. There is wisdom in others' counsel that will keep balance.

Curiosity - Joyful Life

Though I've progressively moved to the the heavier places curiosity leads us into, I want to remind you about the joy of curiosity. The sheer childlike wonder of a curious spirit is a beautiful thing. When we stay in a state of curiosity, it has a surprising way of keeping us continually searching, and yet it brings us a sense of resolved contentment. We should never lose this. Eleanor Roosevelt said, "I could not, at any age, be content to take my place by the fireside and simply look on. Life was meant to be lived. Curiosity must be kept alive. One must never, for whatever reason, turn his back on life." When we hold to curiosity as our navigator, we will remain

humble in our creative pursuits. Albert Einstein, the amazingly talented genius, said, "I have no special talents. I am only passionately curious." Was it his curiosity that made him the gift that he was?

3

HONESTY

Living an artful life requires honesty. True art is not simply creating an aesthetic form that is separate from the spirit. That is merely decoration, or performance, or prideful presentation of something base and carnal. True art is not carnal. True art engages the soul, mind, heart, and spirit. This engagement requires authentic expression. Without authenticity in our art, we merely have object without essence, and without essence there is no art.

As artists, we have been given the great gift of telling honest stories to the world. When an honest story is told, even when we don't like or agree with the components, the rawness pulls us in and knits our human hearts to the experiences of our existence together. Furthermore, where we find honesty, we usually find power for hope, for change, for redemp-

tion. This is the goal of art. It is the job of art. It is the reward.

Jesus lived and moved and spoke in raw and authentic ways. It was one of the elements of his nature that was extremely attractive and caused people's hearts to be given over to him. He cared more for truth than pomp. He spoke in real ways and demonstrated real power by continually going against religious expectations and simply being real. He spoke straight to the woman at the well about her sin which was the root of her sorrow; he spat in the mud and put it in the blind man's eyes; he challenged those who would throw stones at the adulterous woman about their own inauthenticity. This challenge to know ourselves, to be healed, and to face our own hypocrisy is a constant quest for us all, but we, as artists, are called to make an honest expression of that quest. We are called to tell the Great Story. This takes courage.

Believing Lies

In our quest to live an artful life, we often get trapped by believing lies about what it means to be an artist. Many believe that they must be like other artists they admire in order to be worthy of the *title*. Others have gotten sucked into the modern cultural belief that to be an artist means that you must have a collection of accolades, or be successful financially with your products. Some take their title as artist

because their work is thought of as perfection in their medium. The integrity of art is not in the perfection of skill or even its statement, the integrity of art is found in its honest expression. Others naively believe the lies that simply doing a creative thing makes you an artist. Though that is a lovely thought, it is not true. Being an artist goes beyond making art.

Being an artist is a type of living - a way to process life. Artists truly do think and move and live differently. They exist in the *in-tune* place with Creator so that the outward structures of life do not press in to conform them to its ways. They live from the inside-out. They function out of the place of connection to the Creator, even when they are not consciously aware of it.

It seems some people are born artists and others are not. I do not adhere to that way of thought. I believe we are all inherently designed to be artists and to live artful lives. All children are creative and without fail, they process life in the place of the mystery that is required for honest artistry. Their naivety and passion for discovery keeps them in artistic mode. It is very sad how quickly some family structures, schooling, and societal pressures shut down the artistic ways of children. Thank God many of us survive it. These are the ones who we call artists - the crazy survivors. But see, we all once were artists. Perhaps it was last seen in your life when you were

two or five or twelve. No matter when it was that you last felt in touch with your God-given artistry - that naive place in you that simply "knows" what your unique art looks and feels like - it is now time for the recovery of your artistic nature - your true self. It is time to awaken. It is time to embrace truth.

Telling Lies

Often along our creative journey, we will come into connection with an artist who we admire or we may look to great art movements and famous artists from the past and see that as the epitome and conclusion of who we are meant to be as artists. This looking to others can help us grow, but we must see it as inspiration for our own direction rather than the ending point for our journey. Striving to be like the greatest thing we can idolize puts us on a frustrating journey to become what has already became. The world is waiting for you, not another version of another. To believe that we must create art that is like someone else's expression is a way of telling lies to ourselves. We must see clearly what it is that we have to give to the world from our own personal revelations and that will be the dynamic of our own story - a story that is merely a part of the greater human story.

It is not wrong of us to admire and learn from others' expressions. Some of our greatest thoughts and work can come from peering into others'

processes, techniques, and finished works. The synergy that can be created by simply opening up to the artistic expressions of others is what we are all after. Imagine a world of artists who know themselves and who express their authentic stories aligning in synergy with one another. What a beautiful collaborative tapestry! We should embrace every opportunity to learn and share with others in their artistic journeys, giving and receiving along the way. We never really create in isolation. Everything we encounter in life becomes a part of our artful journey.

In the context of sharing our artistic journeys, we need to be sure that we do not believe or tell lies to ourselves and we must also be sure to not tell lies to each other. We so often want to protect our image. Image can be a huge issue for an artist because the very nature of art is something which is to be presented or displayed. That display can be intimidating. As artists, because art is expressive of who we are, we can be tempted to be purposefully inauthentic in order to protect ourselves, to boost our ego, or to simply hide from truth. There can be many ulterior motives for doing what we do. We must ask ourselves why we make the art we make. We must tell the truth, even if the truth is that we don't know what the truth is.

We often don't know what the truth is and we are afraid of the search for it. It is easier to structure

our lives on things we've been taught to believe. An artful life has a way of rocking that boat. To truly have confidence to live an authentic life and create authentic art, we must search for truth in our own way. We need permission to delete our inauthentic programs - our conditioned upbringing, education, religious systems, even our past abuses and trauma. This permission will free us to create in new ways that breathe with honesty. The journey is the real masterpiece. The art is the reflection.

Everyone deals with areas of not knowing who they are and of sometimes putting on alter-egos to find acceptance. This will show up in your art and that is totally ok. You may not see it until you have grown out of that season and when you do, you will say, "Oh, that's who I was then," or possibly "Who was that?" There is grace for those times. We should learn from them. It is a normal part of growth. We all, in every season of our lives, have an evolving understanding of the authenticity of our lives and art. That's all we are accountable for. So often we get caught up in the religious need to express the divine truth. I'm certain that divine untainted truth does break through at times in our art, however, we are all on human journeys, and if we all hit the mark every time with ultimate divine truth, there would be no need for grace. There is need for grace. We must give ourselves freedom to walk our human journeys and give grace to one another in that. God does. We only know and express the truth that we now under-

stand. A life lived in humility covered by grace produces beautiful art and beautiful artful journeys.

Telling the Truth

So, how is it that we can tell the truth in our art? There are five things that can be highlighted here to guide you in telling the truth. We need to tell the truth about who we are, where we are, what we need, what we want, and what we fear. Being conscious of every thought and embracing every part of ourselves, even the negatives, will bring us into authentic truth. No matter if our understanding does not align yet with the ultimate divine truth - that perhaps none of us truly understand - it is a truth that pushes you and others towards God. Living and creating art in this way is honest.

Who We Are

The age-old struggle to know who we are is exasperated by the mere state of being an artist. As artists, we are always outwardly expressing from this place of who we are. It can be difficult and also irritating. Artists, I believe, are by nature fast evolvers. We are always changing - shifting from one season to another. Our love for the new keeps us pushing into the next part of our growth, so keeping up with who we are can be quite exhausting. Making artful expressions of all those seasons can be almost impossible.

Because of that constant evolution, I think it is wisdom to know who you are at your core. You must know, embrace and accept the real you. You may have to let go of the "you" that you think you are in order to know the real you. Only you know if you do not know yourself. The inauthenticity will cause you to have fear, no satisfaction, and you will probably be creatively blocked or frustrated. Emotional woundings can deeply change the perspective of who we are. So often we cannot see the real one that we are because we only see pain. We need to seek healing. Outside influences like other's expectations and societal norms can tell us who we are, and many of us believe the outside world instead of our inner hearts. God speaks to the heart. We must listen.

Each of us have within ourselves our own world - our own way of thinking, processing, and believing. It may take some remembering back to childhood to get in touch with that world again, but once we find it, our own little niche where we feel comfortable, we will know we have found ourself - *our self*. When you can see your self in this world, then you will know yourself. It actually is the place where we meet God. That's the place from where you make art. It's the place you love and what you love is so important to knowing who you are. What are the things that inspire you? What do you love? What are the quirky things about you that are different than anyone else?

These are the things that make you unique and they definitely are elements for expressing yourself in your art.

Where We Are

As mentioned above, the evolution of who we are is always changing, so to be honest in our art, we must know where we are. Are you in a place of joy or mourning? Are you growing or backing up to firm up foundational things? In your skill development as an artist, are you a beginner or advanced? These questions provoke answers that we must continually be asking ourselves. The answers are often found in the creative process. Through the introspective nature of art we may actually find the season we are in and the season we are heading into. We even at times get prophetic glances of the distant future that we are pressing towards. It is intriguing how art and life parallel one another. Raw gut-level honesty in our creative process brings us to honest conclusions about ourselves and our God. It takes courage to express that - courage tempered with wisdom.

Too often we as artists get caught in a past season of expression so that the work we are creating is not from the place where we currently are living. This disconnect can happen because we are familiar with the old way and it is easy to stay in what we know. Also, outside influences like financial success or

others' praise of our old season can hold us back from being authentic. An equally valuable thing to keep in mind is that we must be wise to not push too far or too quickly into our hoped-for future season. If we keep simply following the cues for each step, we will find our way into the present in perfect timing. There is great gain in contentment. Learning to let the work we create be from the current place where we are is a satisfying way to live an artistic life.

As we evolve in life and art, it is important to remember that you may not always be able to take the people you have in your current season with you into your future season. See, they have a certain picture of you - the you of a certain season. Unless they are willing and able to evolve with you, they may not be able to see the new view of who you are becoming and where you are going. Many people will resist your transformation and they may resist or reject your creative expression as well. Don't worry about their perception. Their path will lead them to where they are going. You must go where God is leading you. Don't let their perception block you from having a clear view of the place where you are and the art you must create.

What We Need

Being able to speak what we need is something we learn even as toddlers. Think of a mother saying, "Use your words," when the toddler grunts for a

drink of water. The child quickly learns to state clearly what he needs so that he can have what it is he is after. We would do well to take a lesson from that scenario. As artists we must be honest about what we need. Do we need more instruction? Different materials? Space? In order to be honest, we must be able to clearly state to ourselves and perhaps to others in our lives what it is that we need. This can be very practical such as needing more space for a studio or a refocus of time management, but we may also have emotional, spiritual, or relational needs that we should clarify and voice in our art. As I have said, art and life run parallel, so if we are in a place of emotional distress and we need healing, then we should be honest about that in our life and in our art. If we are in need of joy, or friends, or conversation, or movement, then we should freely express that in our lives and in our art.

Expressing needs does not make one needy - it makes one wise. If a singer has a great need for healing but inauthentically continues to sing joyful songs because of her desire to not express the need, then the song is going to be flat. If she would, in turn, sing authentically and rawly from that place of need, the song - the form of expression - will be powerful. The song itself will cause the healing to come. If a painter expresses the rawness of pain during a mournful time of loss, the painting itself - the process and the product - will provoke the shift to joy. When needs are authentically expressed, I

believe God, ourselves, and other people as well, see and feel this asking and the provision for the need begins to find its way to us. In a place of trust, need attracts sufficiency. This is the power of expressing need in our art. It brings the solution to us. It's a type of prayer.

What We Want

Just as expressing need is important in being authentic, so is expressing what we want. What do you want? What do you want in your life? What do you want in your art? I'm not going to go into a long treatise about the concern over selfishness, I'm simply going to ask you to take a faith-filled leap with me to believe that God is a good Papa and he wants you to want great things! In the place of faith, it is so powerful to express what you want. In our lives we so often think about what everyone else wants for us, from us, with us. There are definite times, especially when you need to focus on honesty, that you simply ask yourself to clarify what you really want.

Do you want more joy, another friendship, more money, a closer connection to God, better health, more inspiration? Nothing is barred here. Simply express what you want in your life and in your creativity. As with need, when you express the things you truly desire in creative ways, you are attaching faith to those desires, and it actually causes God to

move those things your direction. When you express these wants in your creative expression, you are pondering them in your heart, you are speaking them with your mouth and even at times working them out with your physical body such as in a dance. This is powerful. As a man thinks in his heart, so is he. (Proverbs 23:7). When we ponder the things we want in our heart so that we may creatively express those wants, then something happens. You start becoming the one who has the things you have desired. God loves to link provision to the desires of our hearts.

What We Fear

Insecurity and fear can be helpful things to express if we look at them as tools rather than things that we should hide away. Honest expression requires that we express our fears. Fears gone unexpressed only hide like foxes behind bushes waiting to eat up the tender things in our lives. We can be conditioned to believe that we should not express our fears and that we should only be about positivity and faith, but we are not religious robots who never face battles. Our human journey includes fear and trouble. When we relate this in our creativity and lives, it actually causes our hearts to be knitted together and knitted more closely to our Healer. There is power in expressing our struggles. It gives our hearts places to sit together and wait for grace.

Often in Christian circles, we push out fear quickly and give it no room for expression. This is not healthy. The facade that is left in the absence of expression of fears and sorrows is a sounding gong. There is no love in it. Love relates. It causes you to know that you are not alone in your wretched fear. Love reaches out and says I understand where you are, what you fear, and I want to take your hand. This is the power of art which freely expresses our fears. This is honest art that will span the bridges between those moments when we are in fear and those when we are in faith. This art is the earth to heaven call out. God answers it because it is true. It's like the story from Luke 18 when the man came to God beating on his chest expressing his fear and then the Pharisee came expressing his prayer in the "right" words. God would rather hear our beating chests. If we need to beat our chests creatively, then we should do that. This is honest art.

The expression of fears in our art can actually cleanse our souls from the fear's power. Have you ever spoken to a friend about something that you had been fearing and even as the words came out your mouth, you realized there really was no need to fear. There is just something about getting the fears out of our heads that causes the weight of them to lift. We realize the thing we fear is false evidence. Expressing your fears in creative ways: a song, dance, poem or painting, can actually dispel the fear so that

it has no power over you. Try it. Sing a song about your fear of loss. Paint the darkness that ails you.

Core values

As we think about honesty in our art, we must center our entire creative process, the creations we make, and even our creative relationships on our own core values. Your foundational values about honesty must be present in your creativity. We should never separate the life we lead from the words we speak. Our creative expressions speak. Make them truthful. In order to speak honestly in our art we must know ourselves to the core and be confident about that expression. We must not be people-pleasers. We cannot be servants to others' expectations. We have to be true to what we want to say without other's opinions swaying us with inauthentic directions. We must loudly speak our heart.

As in all communication, clarity and being direct are crucial. This directness can show up creatively by being bold with words, or crisp with movements, or extravagant with color. Being true to your core is about finding the creative elements that make you striking. Being direct takes confidence and fortitude. This kind of assertiveness is the core element of all great artists. They knew what they were doing. They did not apologize for their creations or their creative processes. You must be the same. Believe in yourself.

Know your unique message. Say what you need to say. Stick to your guns and demand respect.

Wisdom

With all this said about being true to your emotions, saying what you need to say, and confidence in expression, I would like to give a word of caution as well about using wisdom in all this. Wisdom is to do the beneficial thing, not the careless thing. Artists are notorious for being passionate and oftentimes, reckless with their passion. Honesty should cause a response that is redemptive.

Art is a tool for digging in the soul and when the soul is dug, often raw truth comes out in ugly expressions. These expressions are not always for everyone's viewing. There is integrity in privacy. No one wants to see our emotional vomit on a canvas. Respect others and have wisdom about sharing. Honesty in art is not a license to be irresponsible with your expression. We, as artists, have a responsibility to be gatekeepers. We should be discerning about the times and seasons for sharing our own personal truths and the truths of our cultural climate. In this sense, we truly are ministers. May we carry that title well.

4

IMAGINATION

Imagination is a tool for transporting our minds and spirits from the ordinary mundane way of life into the beauty of God. It's a wonder and it's something we should embrace and welcome into every moment of our lives. Imagination is a vital element for living an artful life. Without it, an artful life is impossible. Art, in the traditional definition can be mechanically produced without imagination, however, mechanical living is the antithesis of artful living. Imagination is a medicine for a fatigued life of normalcy. Grinding gears and mechanical output do not serve us or the world very well - they simply serve our egos. Imagination causes a spark that ignites new and organic processes which are life-giving, rather than life-draining. It is our choice how we want to live. May we choose to live an imaginative life. Albert Einstein said, "I am enough of an artist to draw

freely upon my imagination. Imagination is more important than knowledge. Knowledge is limited. Imagination encircles the world."

Child-like

Children live in the place of imagination. Even the smallest child will create imaginary places, people and stories. They often live in the magical place of unreality. It's the Narnia place C.S. Lewis writes about in his prophetic story about kingdom living. The place of imagination is the place of spiritual connection and all children do it innately. They do not have to be told how to imagine. They just do. They are designed by God to commune with him in this way. We should learn from this. We should embrace the place of imagination, knowing that it is the place of meeting God. It is the place of presence. Matthew 19:14 tells of Jesus welcoming the children to come to him. He said the kingdom belongs to those who will become like little children. Imagination is one of the keys to becoming again like a child wondrously living in the kingdom.

Vain Imaginations

When we think about imagination, we may also think of another scripture - the one about casting down all vain imaginations. Imagination is the gift of God

given to us all so that we might experience him. Imagination is the vehicle which takes us into the spiritual dimension. We can steer that vehicle into dark areas or areas of light. This scripture, 2 Corinthians 10:5, tells us to cast down every vain imagination that exalts itself against knowing God. The key message here is to cast down those imaginations that take us away from knowing God, so in other words, only those imaginations which are impure. So, what can we gather from this? Because we see that children have the capacity to embrace imagination in a pure and holy way, we can conclude that our Creator is the giver of imagination. We are to cast down the vain imaginations that take us away from knowing God, however, we are to embrace the imaginations that cause us to know him. How do we do that?

Learning from Nature

We learn in the scriptures that the invisible attributes of God can be understood by the things we see in his creation. Romans 1:20 says: "For since the creation of the world, His invisible attributes, His eternal power and divine nature, have been clearly seen, being understood through what has been made..." We may not think of this as imagination because his creation is what we clearly see in the natural with our natural eye. However, to really see creation with eyes of spiritual understanding takes

imagination. We can look at a tree swaying in the wind and simply analytically know that this is happening in a physical way, or we can step into the place of imagination and understand that God designed that wind to blow and he sovereignly keeps it blowing in the *now* moment and that as it causes the tree to sway, we see the flexible and beautiful way it dances with the wind. We see a God-moment. This takes imagination. This kind of spiritual under-standing causes us to know God as creator - to know his dance-like nature, his genius of design and his amazing beauty. See how this example helps you to know the nature of Creator, rather than just the products of the Creator? Understanding the invisible nature of God takes a beautiful imagination.

Thankfulness

Embracing imagination so that we may know God is linked to thankfulness. Continuing with the prev-ious scripture about knowing God through an imaginative view of creation, the next scripture, Romans 1:21, shows us how this lack of under-standing about imagination causes our hearts to be dark. It says, "For even though they knew God, they did not honor Him as God or give thanks, but they became futile in their speculations (vain in their imaginations), and their foolish heart was darkened." When we do not see things in the purity of imagina-tion with a heart that is thankful, we are continually

spiraling towards darkness and this is when our imaginations become futile - vain. There is a challenge we all face as we "grow up." We let the child-like wonder get lost in unthankful ways that do not honor God. Then we are left with only vain imaginations and foolish hearts. The key back to the beauty, power and divine nature of God is found in the door of child-like imagination accompanied by a heart set on thankfulness. We need to look for ways in which we can be thankful, making it a quest to find treasures for building a grateful heart. Ann Voskamp in *One Thousand Gifts* said, "And when I give thanks for the seemingly microscopic, I make a place for God to grow within me."

Connecting to Imagination

To connect with imagination, we must first turn our hearts towards it - and our eyes. Mark Twain said, "You can't depend on your eyes when your imagination is out of focus." The inner eye of imagination is powerful for changing your life into a more meaningful existence. Imagination will change your nature. If your imagination is focused on God, then the nature of God will refract into *your* very nature. Imagining with God opens you up to the recreative dynamics of the Spirit in your own soul, mind and spirit. As the Bible says, "As a man thinks, so is he." Do you purpose to be imaginative? Have you set your vision on having an artful life?

Body Awareness

Our openness to imagination is linked to our physical existence. How do you feel? The answer to this simple question can give you clues of your capacity to step into the realm of the Spirit. If you are weary or tired, it's likely that your spirit is as well, and your mind. If you are frustrated and anxious, the capacity to believe for a free flow of imaginative experience is blocked. So how do you feel? Your body wants to work for your creativity. How can we align our bodies to be in synergy with our creativity and furthermore, with the creativity of heaven? See, we all have the deposit of creativity inside us. Creativity is the breath of life that we need to inhale so that we may exhale the glory of God.

Breathing Deeply

Deep breathing has many benefits that are conducive to experiencing a deeper imagination. The body, mind and spirit is in constant communication. One effects the other. Slow down and be conscious of your breathing. Feel your breath. Be aware of your rhythm. Focus on the inhale and exhale and watch as purposefully breathing deeply will send ripples of calm throughout your body, mind and even your spirit. Your spirit is lifted as your body aligns itself with the perfect design of breathing at full capacity.

The benefits of breathing deeply goes beyond what I can explain in this short section, however, I'll lay out a few examples. Exhaling actually rids our bodies of toxins. The release of carbon dioxide is a natural waste of our bodies metabolism. Deep breathing releases tension in our muscles and brings clarity to our minds. Our bodies and minds require oxygen to function properly, so taking in a full capacity of oxygen actually frees us to imagine because our bodies are not having to work so hard. Breathing relieves stress and improves moods. Deep breathing increases positive neurochemicals in the brain to elevate moods and even combat physical pain. All the positive results of breathing in deeply and exhaling fully naturally opens up our imaginative minds. Try it. For three minutes, sit quietly and focus on inhaling and exhaling as deeply as you can. You will feel a lightness in your mind and spirit and you may even begin to see colors and images in your mind's eye. God designed us to continually be connecting with him through even the simplicity of taking deep breaths. We are designed to be people of imagination.

Environment for Imagination

Healthy environments are crucial for creativity. I would encourage you to pinpoint your happy places and purpose yourself to be there as much as possible - and with the people who make you happy in those

places. When an environment is stressful or tense, creativity and imagination are squelched. Like a lot of creatives, I'm a real *feeler* in the Spirit, which can be like a curse at times. If I pick up on tension in a room or with a relationship, it causes me to want to hide from that place or put my full energy into resolving the tension. That shuts down my imagination and therefore my creativity. There are ways to counter the shut-down. The following are my suggestions.

A healthy environment for imagination requires that emotions can come without restriction. This may not always be possible with other people around because not everyone can handle that kind of freedom. Also let me say that we do not use this as a license to be emotionally irresponsible with ourselves or others. When you find a place and people in which you can just allow your emotions to flow from an authentic place, then you have found treasure. Imagination lives in places and with people like that. If you do not have that place with others, you can still have it with yourself. Imagination is nice collectively but it is equally as nice to sit alone and ponder. Sometimes it is a solo process. Take peace in that.

Imagination needs room for thoughts to come without judgement. We should give ourselves this gift. Journal freely the words stuck in your head. Doodle the imagery that spins. Dance the rhythm of

your life circumstances. Let all your thoughts come without judgement or analysis. This frees you to imagine as those thoughts flood through. It actually helps you to find the path you are traveling and some of the answers you need. Even the angry or ugly or depressing thoughts that come through your life are clues for imagining the life you need to step into - or perhaps step out of.

It is a rare gift to find friendships, family relationships and community where you can freely live like this. If you have it, keep it at all costs. If you do not, search until you find it. I've found few relationships in my own life where I can just be this way and it works. I decided a long time ago to be this way anyway and if it doesn't work then I keep being free and wait for the journey to take me where I need to go. You must live fluid like that. Judgement is an ugly thing. Don't let it kill your freedom of imagination.

Movement

Movement is a tool to pry open your imagination. I have a friend who went through a painful divorce. In his recovery, he began to hike and run. The craving he had to run likely came from the place of needing to escape the pain. He paid attention to his body. He asked himself how he felt. He felt like running. As he ran, his imagination opened because it was the

place where he allowed his emotions and thoughts to pass quickly through his mind, soul, and spirit as his feet repetitively pounded the ground and his body passed through space and time. The emotions and thoughts were fleeting, however, he began to experience vivid lines of poetry that flooded in so rapidly he could barely keep up with it. His imagination had opened. The fleeting emotions and thoughts were captured through the filter of imagination in order to become healing words to mark a journey and minister to other hearts in pain. See, God designed us to move for meaning not just function. His richness meets us when we listen to our bodies and hearts and move with the rhythm that seems right. Try it! Twirl your hands in the air. Get up and take a walk in the garden. Dance like you never have! Run. Run straight through imagination and into your artful destiny.

Sound and Silence

Sound is something that we often take for granted. The power of sound and even the sound of silence is a vital tool for imagination. Have you ever sat quietly and listened to the symphony of the sounds of the forest or a busy city street? Has your mind been flooded by closing your eyes and listening intently to a piece of music? Sound is imaginative and it spawns imagination. We should be aware of the sound quality of our environment and make it as

conducive to artful imagination as possible. This is a key to an artful life. Eighteenth century writer and poet, Johann Wolfgang von Goethe said, "A man should hear a little music, read a little poetry, and see a fine picture every day of his life, in order that worldly cares may not obliterate the sense of the beautiful which God has implanted in the human soul." The sense of the beautiful is always there. Do you hear it?

Sound is an imaginative healer. After long days and especially during difficult seasons in my life, I find myself at my vintage piano which is a little out of tune in the loveliest of ways. It has its own unique sound. I do not know how to really play the piano. I am not trained, but I've sat at that piano so many times finding the keys that resonate with my emotions, that after only a few minutes I find my imagination lost in imagery as I strike the keys that sound like pictures in my mind and soul. Often my difficult memories and thoughts are the first images, but almost without fail, the imagery turns from those emotions into beautiful uplifting imagery and music. The sound gate to our soul is powerful and effective for connecting with God. One does not need a piano. Drumming your hands, singing, humming, and clapping - all these are tools for making sounds which resonate with your imagi-nation. Leonardo DaVinci said, "Do you know that our soul is composed of harmony?"

Dream States

Dreaming is a powerful way to experience the place of imagination. Imagery produced by the sleeping mind is a universal experience. Isn't this innate quality a beautiful gift we have been given? It is part of the divine nature that was breathed into us when God breathed into Adam and made him a living being. Dreaming is an imaginative expansion of the mind that is often a composite of familiar experiences from our lives, memories, and thoughts. Our ordinary dreams can be very significant and meaningful, helping us to uncover our true feelings and guiding us in life. Meaningful dreams are discussed throughout the scriptures. Joseph was given the dream of how the Lord would lift him up over his brothers. Gideon knew what to do in battle simply by hearing another man's dream. When Jesus was a baby, Joseph was given the dream to warm him to take Jesus and Mary to Egypt for safety. We should give thought to the meanings to be found in our dreams.

Dreams can take us into the place of the spirit, through ordinary dreams and even more intensely through a state called lucid dreaming, which is where a person is kind of between the states of being awake and asleep. Lucid dreaming is where the dreamer is aware of dreaming and can even seemingly make conscious decisions within the

dream. Often people say that in lucid dreaming it is as if they have left their physical bodies and that they go into different realms. We can easily agree that dreaming is a state of the subconscious, however I think we should ponder the idea that the subconscious is actually very connected to the spiritual realm. We are spiritual beings in earthen vessels. Opening up to imagination will actually cause your dream-states to increase in frequency and with deeper meaning.

Dreaming while awake is a gift from God. As day-dreamers, we let our mind float away as we experience other places by utilizing our imagination even while we are physically located in one place. This transporting of the mind can be simple imagination or it can also move into more complex areas of imagination where Holy Spirit is engaged in an intense way and we actually go places in the spirit realm. This state of going somewhere in the spirit can be focused and purposed through centering on Holy Spirit and praying for such an experience or it can be what we would refer to as a visitation, where we are caught up unexpectedly. These states of mind, or should I say spirit-states, are referred to as visions and trances. We can read about many spirit states like this in the New Testament. Peter saw a veil coming down from heaven that influenced paradigm shifting revelation. (Acts 10) Paul was visited by the Lord while in a trance. His life was changed forever.

(Acts 9) In 2 Corinthians 12:1-4 Paul writes of a man who was caught up into the third heaven. Paul was not sure if it was an in-the-body experience or an out-of-body experience. John, while on the isle of Patmos, went through the open door to heaven and saw The Revelation. All these experiences require being open to imagination in your life. The actual imagery is seen and encountered through the place of imagination. We do not typically agree with that as Christians because we want to super-spiritualize things and act as those who see heavenly things are elite or specially anointed in some way. The gift of seeing images - imagination - is for all of us.

We can purposefully open up our imagination to the dream-state by simply relaxing and letting our thoughts float out of our minds in a visual way. We should ask Holy Spirit to visit us through our imagination. As we do this, our spirit will become activated and we will be imagining with Holy Spirit. A simple meditation of sitting quietly and praying for your imagination to open up and be engaged with the Spirit can cause you to be actually flooded with holy daydreams. We can do purposed and faith-filled activities to help us dream, such as soaking prayer, focusing on a symbolic or metaphorical image that is stirring in our spirit, or just simply allowing our minds to go into the fantastical world of make-believe. God is a fun Papa. He wants to tell us fantastical stories. Purpose to free up your mind so

that your imagination can flow into the dreaming place with God. Trust Holy Spirit to lead you. So often we fear daydreaming because we do not trust that what we see is from God. Once you trust him and see this working in your life in divine ways, you will know the truth of it.

A life that is awakened to imagination is rich and meaningful - never boring. May we be mindful to let go of the filters that block us from extravagantly imagining. Simply absorbing the process of our God-given imagination, feeling it, knowing it, and moving through our lives with an intuition birthed from that place leads us into an artful and Spirit-filled way of living. Imagine! Imagine big!

5

LIVING FLUID

In our contemplation of living an artful life, we should consider the rhythm in which we move. Our rhythm is so important. We can look to the rhythm of nature to understand God's natural rhythm for our lives. Water is the fluid of life - wherever it flows, life springs forth. The very nature of water is to bring a refreshing.

We can learn from the flow of water. It always flows in the path of least resistance. A stream flowing down a mountain will meander its way around every obstacle. Stones in its path do not stop it. It flows over or around with ease. The phrase, *the path of least resistance* is often used in a negative sense to convey that those with little fortitude will always choose this path. I'd like to present to you another way of looking at *the path of least resistance*. In our culture we

tend to believe that the things we desire and the things worth having only come by hard work. We have a striving mentality. If we learn from God's natural order by looking at the rhythm and movement of water, we will realize that a beautiful flow can come by following its design.

What does this path of least resistance look like? It means to simply go with the flow; to follow where you are seemingly being led. So should we just do what feels good? I know that has negative connotations, but yes, if we are connected to Holy Spirit, and his guiding nature is for us to be in peace and joy - then we should follow the things that bring us peace and joy. There is an innate compass inside us that will follow the correct way, if we will simply get in tune with the flow of the Spirit.

As we begin to pursue the desires of our hearts and the God-dreams that are inside us, there will be troubles, trials, and many difficulties. These are like stones or dams in our fluid path. We must move with the rhythmic flow of water, turning and pressing around and over the obstacles. Water is a powerful force. It is tenacious. If you have ever tried to stop a water leak, you know this. We must be tenacious like water. We must be persistent to press through or go around every obstacle in order to stay on our ordained path. We must trust the natural flow of things.

Water is refreshing. It brings life. When water is given to the roots of living things, new life springs forth. When moving water is given to stagnate water, the very makeup of the water is refreshed and made new. In Ezekiel 47, we read of the river flowing out from the sanctuary giving life to everything it touches. As the trees grow by the river bank, the scriptures show us that the leaves of those trees will be for the healing of the nations. How might we begin to take in this living water so that the very fruit of our lives will be healing to the nations? Of course, I'm speaking metaphorically here, that if we can take in the living water, we can be refreshed and bring healing. Though we are looking at the metaphor, there is something to be learned in the study of the flow of water. It is nearly unstoppable.

In our studio, we have a humidifier and when I empty the big container of fluid water, I'm amazed that so much fluid water is actually pulled out of the atmosphere. It makes me think about how this very fluid water, as I'm pouring it out, exists all the time around my being. I imagine how it must be pushed and shifted through the air simply by the movement in the studio. If I could see it - if it were not invisible vapor - I believe it would bring me as much joy as a river flowing or spring bubbling up. Imagine the way it floats and meanders effortlessly, always submitting to the movement, never pushing against the movement. An existence without striving to be or go anywhere. How often we want to solidify our

journey, rather than letting it remain fluid or vaporous. We are too often fearful of the things we cannot see or the flow that may lead us into unknown places.

Purifying the Water Within You

Stagnate water forms when there is no movement. On our creative journeys, we can often hit a point where we feel stuck, stagnate, lifeless. There is no rhythm or flow. There are a thousand reasons why we get to these places of being blocked or stuck. Real life happens and it is not always pleasant. This effects our creativity. Despair can shut us down from creative expression and from living an artful life. What typically happens is we shut down and wait for the despair to leave so that we can paint a nice picture or sing a lovely song. If we hold creative expression outside the door of where we really are then we may never open it again.

Stagnation breeds a lot of ugliness - bacteria, parasites and mosquitos that carry disease. This is a metaphor for how a stagnate creative life can breed unlovely things in our lives. We must rid ourselves of the stagnation. One of the best ways is to release the stagnate water. True art must flow out of our inner place. If the inner workings of our soul is in a place of despair then we must simply go with the flow and paint the despair, sing the grief, move with the pain, say what needs to be said. The authentic expression

that comes out of our painful places is often the very key to unlock the door back into the home of peace. If we will embrace the journey, an image or a sound or a movement will emerge and it is that very thing that will break the block. It's like tenacious water jutting up and over a stone. This is living fluid. This is moving like vapor - spiritual.

Seasons

Water flows differently in different seasons. We must trust the seasons of life to be what they need to be. In the winter, the water is frozen and put at a peaceful halt. We must know when there is a need for us to slow down and rest. Often under frozen water there is a life that is kept silently moving, though we do not see it from the surface. In an artful life, we must embrace those times when things are quietly stirring in our spirits. This can feel like a frozenness because there is not much productivity, but if we are truly in a winter season, it can actually be producing a lot of beauty under the surface.

This winter is a time for exploring the depths. It is a perfect time to let ideas stir around, try some things that are new to you without needing to produce a product, ponder the beginnings of a new season, grapple with things that have been buried or that are not yet in the present. In winter, it is important to keep a vision of the summer that will come. As Lewis Carroll said in Alice in Wonderland: "I wonder

if the snow loves the trees and fields, that it kisses them so gently? And then it covers them up snug, you know, with a white quilt; and perhaps it says, "Go to sleep, darlings, till the summer comes again." Song of Solomon 2:11-12 speaks of the winter passing and the spring coming:

> For, lo, the winter is past,
> the rain is over and gone;
> The flowers appear on the earth;
> the time of the singing of birds is come,
> and the voice of the turtledove
> is heard in our land;

The spring is a time for things to emerge. New life comes in the springtime. Our artful springtime will be filled with the emergence of new things. It can be the birth of a painting or a song. It can be a time of breaking out of the cold with a fresh passionate movement. In the spring, our creativity may burst forth or it may be a sweet trickle as we come out of the still frozen of the winter. It's a beautiful time for listening for new sounds just like our natural spring brings chirping birds and brooks coming alive. As water thaws in the warmth of spring, there is a freshness that comes forth. In our creativity, this can be a time of beginning to actually try the new things that were only pondered during the cold winter. The spring seasons of our creative journeys are good times to push out into the unknown a little, perhaps intentionally try a new project or connect with new

friends. You can know if you are in this season if it feels as though you have a craving to move into something new. Go for it. Think of a baby fern unfurling on the forest floor or the growing branch taking on small little tight tendrils that will become mature leaves. The process starts small but it is one of rapid growth. You can trust that if you will live artfully in the season, just taking the faithful first steps, that the growth to the new place will unfold. Our creator developed this process. If you will intentionally align your creative action with the hope of growth, the thing you long for will happen. It is simply His nature to bring it to pass.

The summer is a lively time. It is a time for activity and connection and celebration. When we are in a summer season creatively, it feels like a party. Productivity is high. Creative relationships are buzzing. Fun is being had. I have a favorite line from a song, "Drops of Jupiter," by Train: "She listens like spring and she talks like June." This speaks to me of the progression from the emerging listening place of spring and into the rapid-fire fun of June. Summer is a good season. It is the time for rapid waterfalls and whitewater rafting. The flow of swift waters through sunny landscapes and deep singing forests is invigorating. Enjoy your creative summers when they come. Enjoy them fully. In the summer, the only thing you have to watch out for is overgrowth. You can keep it tempered by remembering, like the song says, to listen like spring and keep talking like June.

The autumn is my favorite season. It speaks to me of warm fires and cool crisp evenings, crunching leaves underfoot, bundling up in scarves and boots, and extravagantly beautiful colors. There is a somberness, a peace, that feels as though it is literally embracing my soul during the autumn. The reality is that in all that beauty, everything is dying. I'm always amazed at the beauty I find in the death-process. Leaves that have started to decay show their extravagance through intricate filigree patterns that remain. Pods of once-beautiful blooming flowers take on a skeletal bold design promising re-birth. Even the dryness of the air because the water has seeped low into the earth seems rejuvenating to me.

The flow during the autumn is ever so deep - like a well that is anciently waiting for the new day it will arise. Autumn is a time for cycles to end and wait for the resting place of winter. It is a time artfully to settle down in your spirit and close up the creative efforts of seasons gone before. It is a time to ponder and peer in to the beauty sitting quietly around you. It's a time to reflect on the creativity that you have enjoyed in the previous seasons. Autumn is a very graceful season. I think it is God's way of showing us that even as things come to an end, His grace is there to help us see the beauty. The Autumn creative season is a time to go deep into a fluid well and find closure so that you are making your soul ready for the resting of the winter to come - and also the rebirthing of a new distant spring.

The Flow - Spontaneity

Spontaneity is a wonderful part of living fluid. I love to catch a whim and take off on an adventure. Painting is like that for me. I sometimes plan, but to move spontaneously as I paint is the most joy. I also like to sing spontaneously and dance just whenever. It has taken me many years to cultivate that freedom. I have found that when you move in a joyful spontaneity, creativity automatically awakens. It is childlike. It's freedom. Creativity can't help but come alive in the presence of freedom. Purpose to live a life of spontaneity. It's actually not an easy thing to do. Our own rules for how we should live pen us down and keep us from living spontaneously. We must break our own rules. I encourage you to take a drive to an unknown destination. Call a friend to have lunch on the spot. Walk up to someone and say hello and ask them for their story. All this is practicing an artful life. Art parallels life. If you can live spontaneously, you will create with spontaneity.

Contentment

Contentment is a great joy. There are so many things that can bring us dissatisfaction and so much that happens in our lives that can truly make us discontent. I'm definitely one who believes that we should fully process the emotional places we find ourselves in, but discontentment is not actually an emotional state - it is a choice. I would dare say it is

even a judgement that we declare over our lives and creativity. Discontentment leads to all kinds of hurting places. Bitterness, sorrow, shame, unworthiness, despair - all these can come from the choice to not be content. It really is a trust issue. If we trust God and the process of an unfolding life, we will be thankful and content with our lives and our creative process no matter what is happening. To be able to love the song before it finds its perfect rhythm; to enjoy the painting even while it is in a transitionary phase; to feel the rhythm of a poem and trust that nuance even before all the words come together - these are the spaces of gratefulness we must find in order to keep our hearts creatively content. Contentment is great gain. Yes, just the place of contentment, rather than the place of perfection in the outcome, is great gain. It's fluid.

Serendipity

Serendipity - what a beautiful word! Webster's defines serendipity as: the occurrence and development of events by chance in a happy or beneficial way. Living fluid requires a belief in serendipity. When one believes in serendipity, then everything becomes about the journey. To simply follow the rhythm with an expectancy that the next chance happening will set you into your perfect flow is a life well lived. Life becomes a rich unfolding of happenings which point to a greater purpose. Because it is centered in the place of expectancy that some way

or another you will end up in your destined space, all of life becomes a treasure hunt. Everything found along the way becomes a clue to the greater calling. All of life becomes metaphorical and Spirit-led. Mysterious. This is the exemplified artful life. When you believe in serendipity, you miss nothing. You are continuously looking for the next clue that the chance might lead you to some good end - or at least to the next good place on the journey.

The intriguing thing about serendipity is that faith is always involved. You can not plan the path. You simply must stay true to the path and the path will keep going. Faith requires trust and it also requires the knowing that we cannot work things towards our goal. We must trust the process and and be open to surprise. Novelist John Barth said, "You don't reach Serendip by plotting a course for it. You have to set out in good faith for elsewhere and lose your bearings serendipitously." I love that Barth saw serendipity as a place. He called it Serendip. May we believe that there is a place waiting for our arrival? Living fluid with serendipity as a guide gives you freedom to trust that the solution to your problem might be something totally novel that you hadn't seen coming. It actually leaves room for new things to emerge, which is the crux of creativity. Look for serendipity in your creative process. Paint without a vision for the ending product. Shift directions easily in the middle of a piece. Sing in a style that you've never tried. Get out of the studio and go for a walk

and see who you might meet by chance that will totally shift your creative direction into a new good thing. Hang out with new people. Look for clues everywhere. Open your eyes and ears and all your senses to catch the messages you need. Trust the Spirit to guide you. Believe in serendipity.

Sovereignty

When we trust serendipity - the random chance of things to lead us to a good place - we are equipping our hearts to believe in the sovereignty and goodness of God. "Every good and perfect gift comes down from the Father of Lights." (James 1:17) When we believe that God is sovereign, living fluid is much easier. I'll never forget during an Unlocking the Heart of the Artist event, when my friend and ministry partner, Matt Tommey, said, "You can trust Him. He's a good Daddy and he desires to give good gifts to us." Though I knew that already, something of that truth lodged deeper in my spirit. It was as though it came alive in me in a way that I had never trusted. We have to trust God deeply like that. There are so many reasons why we may not trust that Papa wants to give us good gifts. We need healing not stronger will. Believing is not about a stoic decision to decide this is the truth. It's about having an encounter with his nature and seeing his love face-to-face. Papa God has your whole life in his hands and he wants to give you every good place that you

must travel to reach the destination he has designed for you. Will you trust the Journey-Maker?

So often we will trust God, but we don't trust ourselves. We feel as though we surely cannot hear God, we don't understand his ways, we miss him continually and we simply mess up. We are good at beating ourselves up all the while we are expecting God to help us find the right way. We need to stop that. It's being of such little faith. Trusting yourself takes faith too. We need to practice being an optimist even in the most difficult times. Our response should always be, "How can I be an optimist about this?" Yes, I know, negative things happen. Life hurts sometimes and horrible mishaps trudge into our lives. In those moments, we have to trust ourselves to get in tune with God's plan for us. God will not invade us. He is not intrusive. We must optimistically hope to see and hear the wisdom for direction.

The scripture about all things working together for our good does not make much sense in the dark pits of horrible times. You could superficially try to have faith and quote that scripture, but I think the truly optimistic view would lead you to ask of the crisis, "Why have you shown up in my life? and "What are you here to teach me?" Then listen. When we can get that real with our circumstances and with our God, we will see his sovereignty. We then can trust the artful life and our own ability to walk it out. We will realize that we can stop struggling and let the

Creator do his creative work in us. Slow down and think about that. How might you ask your life-questions differently?

6

EXPECTATIONS

I am not my job, my social status, my religion, my position in a family, or another's perception of who they think I am. Only God truly and fully knows who I am. I have to come to the resolve that I am the one who has to know me better than anyone else and I must live as the me I know that I am.

Life's definitions of who we are and who we are suppose to be can really tear us up. Our whole lives it seems we are something to someone; we are always trying to be something different than the person we are now in the moment. We have a nagging dissatisfaction with who we are. We need to love ourselves better. Everyone loves the catch-phrase, "Just be" but that is so much easier said than done. We are continually changing and the *being* part of us can be difficult to get in touch with.

Expectations Begin at an Early Age

The pressure of expectations begin with us as children. Our parents and teachers put expectations on us that are usually met with disappointment or reward as we fail at or fulfill those expectations. Their intentions toward us are usually good, however, we learn to live by others expectations and structures. It can actually break the creative spirit we are born with. Creativity usually carves its own path, rather than the one dictated. Some of us are blessed with tenacity to not let go of our creative will. These are the ones that grow up to be called artists. As Steve Jobs so notably said:

> "Here's to the crazy ones, the misfits, the rebels, the troublemakers, the round pegs in the square holes - the ones who see things differently - they're not fond of rules. You can quote them, disagree with them, glorify or vilify them, but the only thing you can't do is ignore them because they change things. They push the human race forward, and while some may see them as the crazy ones, we see genius, because the ones who are crazy enough to think that they can change the world, are the ones who do."

Even as a child, I was always thought of as an artist but I was also thought to be rebellious because I continually wanted to make my own way. My mother

says that even at two years old my favorite thing to say was, "I do it myself!" I refused to let her choose my clothing by the time I was three or four, and by the time I was six I can remember wearing the most ridiculous outfits just because I could. I can still remember wearing my older sister's long burgundy satin skirt as a dress with a belt and a cardigan. I still do that with skirts! There is something of the creative spirit that has to beautifully break the rules. Embrace that!

Don't be a Puppet

We are not here to live up to others' expectations. We must not let others in our lives: parents, teachers, spouses, friends, family members, even mentors dictate our path. We must not let those in our lives talk us out of our true desires. In order to stand in that, you must know who you are. You must love yourself and believe you are worth having the dreams you desire. If you are not in that place of loving and believing in yourself, you will inevitably fall into others' expectations. Be prepared to be a puppet - an unhappy puppet.

Selfishness

Being an artist does not give you the license to be selfish and only be about your own desires. We must love and care for others in our lives. Loving yourself well and being who God designed you to be with

confidence is actually the best precursor to loving others well. When you are being fully you, then you give others around you freedom to be themselves. You are actually blessing others to be fully who you are suppose to be. Get this right. You are not called to be selfish. You are called to be giving by being fully you.

Nurturing The Expectations of Your Soul

Jesus came to save our souls. He cares about the part of you that is the soul - the personality, the emotions, the thoughts. He did not come to us as Emmanuel - God with us - in order to kill our soul. He came to bring us into the greatest good - into an abundant life. He came to save. Therefore, we can know that Jesus wants us to handle our soul kindly. We can treat our soul kindly through embracing an artful life. We must figure out what it is our soul desires. We simply have to ask and listen.

After we recognize our desires, we must nurture them in thought, word and deed. For example, perhaps you have a desire to be an actor on Broadway. Is that desire from God? I think you can trust that if you are connected and sincere with Holy Spirit, then the desire that lies within you is from God. How would you nurture this desire in thought? You should begin to think of yourself as an actor. You should use your God-given imagination to imagine standing on that stage, fully in costume

reciting your lines. You should think about the interesting actors and directors you will work with. You should consider the roles you would like to play. You are intentionally filling your thoughts with positive vision that will project you towards your desire. As a man thinks in his heart, so is he.

How would you nurture that desire to be an actor on Broadway in word? Begin to speak about all the things you will do. Share your dreams. Speak assuredly about the day when you will be there. This is not arrogance. It is a projection of faith. When done with sincerity, these words will bloom into opportunities. Our words are powerful. They have inside them a creative force that brings life or death. (Proverbs 18:21) Listen to your own language. What do you say about yourself and your dreams?

Now we come to the place of working out your expectations in the place of deed. This one is a bit complicated. Again, let's take the example of being an actor on Broadway. You may have never acted on a stage before. This may all seem impossible. Remember to believe that it *is* possible. When it comes to the time of working this out in deed, remember to nurture yourself. Do not step into striving just because you are actually stepping out to do something now. So, if the possibility to be on Broadway is not open to you yet, then you must step out to do what you can. Is there a local theater class you can take? Is there a theater group you could

begin to do small acts with? Will your friends listen to you while you do a monologue? There is always something within your reach that will point you towards your goal. You must ask yourself, "What do I even right now have in my hand that I can use?" Then do it! The Lord loves to see us step into that kind of active faith. He will reward you. He is a rewarder of those who diligently seek him. (Hebrews 11:6) This is how you work out this creative salvation continually on your journey. It's kind of tricky, because it is more about surrendering to the finished work of Christ's grace and trusting him in the process than it is in you actually *doing* anything. Remember always, striving is the enemy of creativity. Fall into the place of simply being you and your deeds will become the fruit of your faith.

Failure

We look at failure too harshly. If we can shift our attention off the failure and onto the solution that was not found but that is still waiting to be found, then we would be better off. Failure can cripple you. It can make you feel hopeless, worthless and that your efforts are futile. It can block you creatively and shut you down from progress. We must keep an optimistic view. When you step out to do the thing you have come here to do, you will succeed. Even in apparent failure, you have not failed, you have only gotten closer to your destiny. Every failure is a way to find another solution. We all know the story of

Edison's multiple attempts at the light bulb. Keep trying! Love yourself enough to keep trying. This is the key. Love yourself.

In my creative life coaching, one of my clients had been artistically unproductive for about four years and was depressed when she started with me. We soon uncovered that she had continually felt undervalued by those in her life who should have encouraged her in her journey, from college art teachers to family members. She had closed down somewhat, when four years prior, she felt forced to resign from a director's position with a prestigious art center because she felt as though they really did not value who she was as an artist and friction was building. In our sessions, she began the journey of overcoming a victim mentality by purposing to nurture her artistic calling and expecting honor from others in her life. She started to find her unique artistic voice again. The Lord began giving her dreams and visions of her unique worth as an artist and we worked together to develop art out of those experiences. She was making tangible the beauty the Lord was showing her about herself and about himself. She was finding her true self. She took some major steps to take care of herself as an artist and to nurture her artistic nature. She began to let those around her know that she valued her time to create and that she thought of herself as an artist. She had to stand up for her artistic self continually. Holy Spirit instructed her to develop a place in her house

where she could get alone to do her art and relax. When she began to value her process and herself, things began to happen. She was offered an artistic job which allowed her to stop working a job she was unhappy with - and the pay was even better. Her relationships began to improve with the people in her life who were dishonoring her. Best of all, the art center who had rejected and misunderstood her four years previously invited her to do a one-woman exhibit of her new works. The exhibit will be a redemptive expression of who she really is in all of God's glory through her. It will be full of unique works that have come out of her journey with God. Depression is gone. Creativity is alive again. Good things are happening. She is now a happy warrior who knows her purpose!

People in Your Life

To love yourself well, you must make choices about the people you allow in your life. As adults, we almost always have the prerogative to choose who we have in our life. At least, no matter what our circumstance, we do always have the right to choose who has power in our life. Don't bring or keep people in your life that will discourage you. Either stand up and put a stop to it or remove yourself from their reach. Discouragement is an ugly evil thing and you deserve better. Creativity and discouragement cannot coexist together. If your creativity is not creating life that shuts out the

darkness, the darkness of discouragement is dissolving your light. You need to stand and fight until you win or you need to run far far away. God loves you too much to leave you there. Now, you must align yourself with his love and make some decisions about what you will and will not be present with in your life. Ray Hughes, a father to creatives and one I'm honored to call a friend, summed this up for me when he spoke it to a group of creatives we were leading in an event. He said, "Don't stay where you are not celebrated. It's not worth it." It's really that simple.

Being Understood

As artists, we can so often feel misunderstood. We can even put upon ourselves a false expectation that we are meant to make people understand us. That can be a heavy burden to carry. Problem is, it usually doesn't work. When we are understood through our creative expression, it is one of the greatest joys, but when we zealously go after it as if it is our life purpose, it can be nothing but a journey of exhaustion. Though we may feel passionate about causes and messages, the Father does not want us to be in constant war. No matter what you perceive we are to be: a warrior, a world-changer, a pioneer, those rewards of those roles are not achieved by striving. They are achieved when we become fully who we are designed to be. We can get caught in the cycle of striving, continually wanting to be understood, then

when we get a glimpse of that, the approval shoots us up to a high level in our ego which usually promotes arrogance. The ego boost is usually short-lived though because there is always something else we will want to have understood, so we get back on the wheel again striving for the next level of approval. It's a deathly cycle.

To find peace, we must learn to live beautifully with our creative passion rather than use it as a weapon for war. We too easily take on a martyr mentality as artists, believing that we are continually facing death because no one will accept our message. The simple key to finding peace with this is that we must come to a place where we do not need to be understood - we only need to understand. If we will shift our focus off our need to be understood by others and focus on understanding ourself and also others, then the synergy of collectivity will occur and positive things will happen. That collectivity will actually help us to understand ourselves better and be able to promote our unique message through a filter of unity and love.

For example, many years ago, I wanted to do a piece of art about abortion. The piece was going to be a horrific vision of the millions of babies killed each year through abortion. The timing of this was during the Oklahoma City Bombing. My first son was a baby and I was so disturbed by the child-care facility that was bombed and the children that were

destroyed by that violence. I, with the whole nation, was appalled that this was an intentional act of destruction upon children. I could not help but to see the irony that the nation would grieve for the children but also be so supportive of abortion. I wanted to make a "slap-you-in-the-face" kind of statement about this by creating a very graphic piece of art about abortion using images of aborted babies. It felt time-sensitive so that it would carry the shock value I wanted it to have. I shared this with an older artist who was a Christian and she told me that she did not think I should do this piece. It discouraged me and I wrestled with the idea, championing all my warrior thoughts of making an impact - of provoking a new understanding and perhaps some change in people's minds about this issue of abortion. The piece I was to create was very graphic and after much research finding photos of aborted babies which I would render into the piece, I simply could not stomach doing it. It was too intense. Because I did not do the piece in that time-frame, I kind of felt like a defeated warrior, until my heart was changed a couple years later.

A Heart-Shift

I remember my heart-shift very poignantly. I was sitting with a friend who had recently come to the Lord. She had always been a wonderful person in my eyes, though she was not in my Christian circles. I was so glad that she had accepted Jesus as her savior

and we were talking about that. She began to speak of how she knew with her mind that she was saved but that she was still dealing with a lot of self-hatred because of things she had done in the past. Not knowing exactly what she was referring to, I began to talk to her about how Jesus cleansed us of all our sins, that everything from her past was forgotten, and that she was whole in this moment. I really believed that for her and wanted her to believe that too. I wanted her to know grace in that moment. She began to confess to me the bad things she had done and when she came to the story of her having an abortion when she was a teenager, the pang hit my chest and I was struggling. It broke my heart - for her, for the aborted child, for the father and the whole family. I sat there broken with the pain of my friend's apologetic and not-yet-grace-understood heart. In that moment I got a flashback of the disturbing image I had wanted to make so that I could slap people in the face - make them wake up and realize the horror of abortion. I sat there realizing that I, too, was in that place of needing grace. I grappled with my own self-righteousness about an issue and saw in front of me the sorrow of a heart that had been affected by it. I suppose grace covered us both, because somehow, I shared the story with her of how angry I had been about abortion and the artwork I had wanted to create, but that I was even now in that moment accepting God's grace over the situation. Together we accepted His Grace and were brought into wholeness. She, for her

mistake. Me for mine. Reality has a way of knocking us off our war-horses and it places instead in our hand the weapon of love. Always remember that art is powerful. We must war with love. May we have grace for it.

Your Own Expectations

Ultimately, we want to know the expectations of God's will for our life. As I've discussed before, you can really trust that if you are asking Holy Spirit for guidance, the desires being awakened in you are most likely his desires for you. You can trust him for divine direction. He placed those dreams in you. We are the only ones who can align ourselves with Holy Spirit, and out of that connection, go after the things we want in life. How do we, without striving, go after the things we want?

Commit to Yourself

You must make commitments - promises - to yourself concerning your life. You must know what it is you want and commit to yourself that you are worthy of having it. Make literal promises to yourself. You may promise yourself that you are going to do certain things to nurture your creativity such as practicing your creativity every day, or carving out one day a week to focus solely on your creativity. Perhaps you promise yourself what you will expect for your life, things like: surrounding

yourself with encouraging people, having a place to worship where you feel loved and where you can express yourself creatively. Perhaps you make commitments to yourself about slowing down, clearing your schedule for friendships, creative outings and purposed study. You are the only one that can make these commitments to yourself. You are the only one that can keep them. Center down to your core desires, beliefs, and loves in order to find the real you so that you can make some promises to yourself about your own expectations.

Create Your Own Plan

When you have given thought to those things that are most important to you and that you want to commit to, then you should develop a plan. Stay away from thoughts about how you have been taught by others for creating a plan. This is about your expectations. Holy Spirit will help you. I understand that you may have commitments to others in your life. I'm not saying that you should not consider them. I'm simply saying that if they are a true commitment, as laid out in your previous step of deciding what you want to commit to, then the commitments you have to others will come out of your place of joy - not sheer responsibility.

Here are some suggestions for helping you get your thoughts together in an out-of-the-box kind of way. Consider sketching your plan rather than analytically

writing it out. Be spontaneous and think visually. Perhaps you could intentionally place yourself in a daydream state and make an audio recording of the way you would like your life to be structured. Perhaps you could dance through your process by imagining the rearrangement of boxes which represent different categories of your life. The point is to be creative even in this planning stage. When we organize our thoughts by traditional means, the "should-do's" can creep in quickly without us intending them to. Most of us have been taught by our culture to actually make plans of how to strive, calling it responsibility, rather than how to dream creatively about the perfect rhythm for our lives.

Discipline

Discipline. Most artistic people do not like that word. It is so boring. We simply need a new definition. We think of that word as being taught or told what to do by someone else and all the expectations that have been placed on us comes rushing back in. So how do we turn that around? Remember that you are the one in charge. You are developing your own plan. You must remember to be true to yourself as you develop this plan, or else you will become your own slave-master. We want to be diligent with the plan we develop for ourselves so it is important to only make responsibilities that come out of your passion. You are not blessed for

the things you have great ideas about, or even the great things you start. You must achieve.

Discipline speaks to us of responsibility. Responsibility is actually about your *ability to respond* to the the choices you make for yourself. When we look at it this way, rather than that it is the result of an action or condition we must deal with, then we will be able to lovingly embrace responsibility and discipline. Discipline speaks of learning. We must learn to lovingly respond to the things we choose for ourselves. Our discipline must come out of the place of love. Discipline is not punishment. It is about alignment. It is about inner cooperation. You with yourself. You with God.

Take Care of Yourself

In this area of expectations and how that influences an artful life, we must take care of ourselves. Taking care of our artful nature and our artful way of living will bring us into a peaceful synergy with the Creator and our lives will flourish. We must accept ourselves as a child of The Creator. We must accept that we are made in his image and that our most instinctual way of life will be to live it creatively. We must also honor ourselves as a creative child of God. When we do not do that, we allow other people and circumstances to rule us. We forget how much we deserve honor and we forget how much creativity links us to honor. Creative life-giving expression attracts honor

to it. It looks like God. Everything magnetizes to that source of life. It is innately known by all creation that the way to approach creativity is through the avenue of honor. Honor creativity. Honor yourself. Lastly, to take care of yourself creatively, you must appreciate yourself. Look at yourself as Papa does. He appreciates the unique way he has made you to be. Celebrate the uniqueness of you. Think about the loveliness he has placed in you. Share it with others. Love yourself. You are one-of-a-kind.

7

CULTIVATING
THE ARTFUL LIFE

There is a certain looseness to living an artful life, however it is actually a very purposed intentional life. There is some cultivation to be done in order to see fruit from this way of living. In this chapter I'm going to discuss some essential things that you can do to live an artful life that will produce a rich creative harvest. Again, I want to remind you that the purpose is to live artfully, not become an artist. You already have everything in you to be an artist; you simply have to find who you really are. You are a creative. I cannot teach you how to be an artist. It is something that can only be found, rather than learned. It's like trying to teach someone how to fall in love. It's simply not possible. As Auguste Rodin said, "The main thing is to be moved, to love, to tremble, to live."

Cultivating Awareness

Awareness is the most important tool for living an artful life. Being aware of the serendipitous messages all around us is essential. We must purpose to look differently at the happenings in our world. Just like Moses, when he turned aside to see the burning bush, God desires for us to turn aside from our ordinary walk so that we can see his burning places where he speaks to us. He will flood our world with his loving guidance if we will look for it and be aware of his presence.

Awareness is more than just looking and listening. It is opening up the soul and the mind to believe for messages to guide you. A life lived in awareness will cause you to listen to the cadence of a friend's voice, watch for the words to be highlighted to you along your path, walk closely to the heart of God. See, you will begin to see the simplest things and actually, all of life, as a stream from the Source of all life to *your* life. This will cause you to move with an artistic rhythm. You will attract good things to you because you will be in tune with all of heaven. This type of living keeps you always pushing into the next *now* moment. It gives you an insatiable desire for living.

Nature Walks

One of my favorite ways to connect with God is in nature. I regularly do this as a devotional time with

the Lord. I don't simply walk though, I peer in to the beauty of *his nature* within nature. It is in these times that he teaches me deep life lessons. He speaks to me through the shape of a leaf, or a cocoon hidden on a branch. The cold wind or the warmth of the sun speaks to my spirit. The flow of the river may inspire a poem or I may take close up photos of the things I'm seeing. The connection is a deep spiritual experience that spawns creative expression. I have had several of my mentoring clients go into nature and begin to peer in to the things they would normally take for granted. They are always surprised at the things the Lord shows them in supernatural ways through the simple act of looking and listening. Nature, whether it is a deep forest, a waterfall, or a city park can open up new realms of understanding for us.

Music

Music is a powerful tool for connection and expression. Our souls are set to rhythms that cause us to align with the Spirit. Even before birth, the ear-gate is open to the place of God's created sound within the womb - nature playing a song to our spirits even before we see or touch anything outside that safe realm. A baby's auditory system develops between seventeen and nineteen weeks. The vibration, inner workings of the mother's body, the sound of the mother's voice and even outside

sounds can be heard by the child. Music is one of the first things we connect with in a creative way.

Music is a landscape where our souls can journey. The depths of sound can take us low into the somber places of soul exploration. The highs can lift us into the heavens. It happens with everyone. If someone cares less for music, I think it is the saddest thing in the world. Henry Wadsworth Longfellow said: "Music is the universal language of mankind." Without a connection to music, I question if there is a connection to oneself, the creative nature of God within us, or to one another. I'm this passionate about the power of music.

The connection we have with music and memory is very powerful. This should not be taken for granted on your creative journey. As the literal sound wave moves into your ear, it evokes places within your spirit that respond to the very nature of God that is within all sound. All music has the dynamic power to move us. We have to find what we love. I love all types of music and tend to jump around from one genre to another. As Christians, we can get locked into the false belief that in order to connect with God, the music has to be worship music, or at best, Christian music. Music is art. Art is not Christian or non-Christian. It is simply art. Listen to the thing that awakens your soul and makes you feel connected to God. This may sound differently than you have previously expected or even enjoyed. Be

open to listening to new music. Intentionally seek out new soundscapes for your soul.

Movement

Movement is essential to all creativity. Everything is always in motion. Do we feel it? Throughout this book, I've talked about the importance of movement. I would like to now encourage you to connect with this essential creative action. Are you aware of your movements? In God, we live and move and have our very being. The rhythm of the Spirit is always in, around and upon us. We must simply recognize it. This creative nature can be tapped all the time. It simply takes some practice. When you are walking, pay attention to the rhythm of your sway, swing, or jaunt. Listen to the sound of your breath as it moves in and out of your lungs. Ponder as you hold your children, shake a hand, do the physical work that life requires. The very workings of life can become like a dance if we are aware of the everyday movements that make up our existence. We must tune in. I had a friend say to me, "Pattie, everything you do, you do it with this 'sway.' You even take all your steps gracefully." I laughed at that, but I also realized that I had not always moved that way, and that it had come to me because I had intentionally focused on the movement of the Spirit within me. It now has become second nature for me to move with the Spirit. I was glad to hear that I move with grace, since I've tried very much to keep

myself surrendering to accepting grace, even in the most difficult times. Isn't it wonderful that we can reflect our inner place? My movement with the Spirit will look differently than yours. Explore what your rhythm feels like. Pay attention to your body and ask Holy Spirit to bring you into awareness.

I once stood on the beach with someone very special to me and I asked if I could hold him close enough to feel his rhythm. He was not in a good place emotionally or spiritually. I stood close and asked Holy Spirit to reveal this area of movement and rhythm to us in a tangible way. His rhythm was jerky and unsettled. It felt like a war. It made me very sad. I often feel the rhythm of my children as I hold them. I can tell by intentionally tuning into the Spirit and their spirit where they are in themselves. I've felt peace and I've felt friction. This is not only a mother's intuition. This is something we all can experience.

With my daughter Timara, I remember how I would dance her to sleep almost every night when she was a baby. I would sing a special song over her and sway and dance in the dark with her until her little anxious fight to stay awake a little longer would give way to a surrendered sway and then a total restful place. She loved movement when she was a toddler and young child. She would dance all the time - always in a ballerina outfit trying out new spins and poses. She loved the movement so much that she was just taken

by the trees and the movements they made as we would drive along in the car. She would sing, "I love trees. I love trees." Then she would go on and on about how pretty they were when the wind moved them. How do we lose sensitivity to beauty like that? May we come back into the child-like wonder of nature's rhythm, our rhythm and others' rhythm.

There are those beautiful places in the Spirit, especially in creative worship, where you feel a divine synergy with others. The movement of the Spirit connects people heart-to-heart and at times spirit-to-spirit. There is a high place in worship where the movement of the Spirit is being felt and expressed in creative ways. It's as if the movement of sound coming from the instruments and singers links with the sway and pull of dancers, and painters capture the sound and movement in a visual expression, even as the minister speaks with a cadence. This expression of layers of movement is so rich - so essential to collectivity. God brings us together with movement. There is a unity to be explored through movement which our traditional structures usually do not allow. We are afraid of that kind of vulnerability. I don't believe Jesus was. I believe he moved beautifully amongst the people.

Metaphor

The black and white of life can be overwhelmingly mundane. We live in a very practical world that asks

us to do this or do that perfectly within the structure that has been made for us. Then enters art. Enter metaphor. Metaphor has the power to show us a parallel, a *life-is-like-this* kind of poetry, so that we can experience a comparison at one point in life and it will mean something to us, but then we see it again years later and the same comparison will mean something different because we have become a different person. Metaphor involves the imagination and the senses. Jesus used metaphor to speak timeless messages. He spoke of the kingdom being like a pearl found, a coin searched for, and seed planted. He knew if he could help those hearing his words to also see, and taste and feel, then he could bring a truth to their senses in a way that would last. This is the power of metaphor.

Metaphor used in our creative process can be therapeutic and healing. In many of my healing workshops, I have participants work with certain fabric textures, specific colors, found elements such as keys or gold flakes. All these elements within the workshop are metaphorical. A dark rough color may speak of wounded dark places in our lives. Gold flakes may be the tangible treasure of God's presence. Each piece represents some greater meaning in which, through the creative action, they may process the things of the soul and spirit. Often we can't really see or touch our emotions, but if we have a symbolic element in front of us, the emotion becomes tangible and we can hold it.

In the literary arts and in songwriting, metaphor is so important. Metaphor can be used to say so much in only a few words. The use of comparisons is a strong tool to have in one's creative tool-belt. In creating strong metaphors, there are some things to keep in mind. I'm going to give you some pointers in a rapid-fire sort of way about using metaphors.

The metaphor should be relatable. Know the audience you are speaking to. You would not use a metaphor incorporating snow for an audience who has never experienced snow. On the other hand, metaphors that are too general can seem cliche. Strong metaphors must be unique and provoke thought. You want your metaphors to be precise and clear. Don't ramble around with metaphorical messages. Express it clearly. In a song, rather than saying the sky was blue like the color of your son's blanket when he was a baby, simply say, " the blue sky was a baby boy's blanket." In a painting, allow one streak of yellow to speak of sunshine. In a dance, let a simply gesture speak volumes. Don't overuse metaphor. It can get annoying to continually go through mental gymnastics to comprehend a message. Say things clearly with a little flair here and there. Lastly, believe in the power of metaphor to speak prophetically. Because of the abstract quality of metaphor, the room for interpretation is wide open. The Lord can really speak through that openness. Metaphor has a way of taking our natural understanding and catapulting it into spiritual

understanding. The transference of this under-standing can actually be a prophetic message. God often speaks in symbols and abstract ways.

Exploration

Expressiveness requires exploration. To live an artful life, we must want to find the new, the something more. Aren't you wanting something more? God is always inviting us into the new places with him to learn something new. There is a preciousness to be found in living for the next treasured moment. If we simply expectantly look for the treasure, we will find it. A midnight sky awaits us with stars to gaze upon. An autumn sidewalk welcomes us to find the perfect pattern in a leaf. God is calling us at all times to come along the journey with him. May we open our hearts bravely to live differently. It takes faith and courage to breath in all of God - to not live like everyone else.

Exploration is essential to creativity. It is that very insatiable desire to learn and experience that nudges us or catapults us into the truly unknown place of a new creation. A life of exploration requires a love for wonder. To expect wonder requires knowing that you are worth being pleasantly surprised. I have found along my journey that those who can not embrace wonder usually do not embrace themselves very well. We must love ourselves in order to trust the unknown path. We recognize that in loving

ourselves, that there is a greater One who loves us. We trust the process of unfolding because we know we have a good Papa who will never leave us or forsake us.

John Lennon said, "There are two basic motivating forces: fear and love. When we are afraid, we pull back from life. When we are in love, we open to all that life has to offer with passion, excitement, and acceptance. We need to learn to love ourselves first, in all our glory and our imperfections. If we cannot love ourselves, we cannot fully open to our ability to love others or our potential to create. Hopes for a better world rest in the fearlessness and open-hearted vision of people who embrace life." May we embrace life in such a way that it actually shuts out the fear we face. There is no fear in love, but perfect love casts out fear (1 John 4:18)

Exploration can be done solely with ambition as its driver, but the reward found in that case is not wonder - it is only achievement. Therefore, we cannot let selfish ambition be our reason for exploration. The artful way is to love the journey - to love the unfolding that comes with the search - to love God through the searching. Expect the beautiful. Empty your mind of restrictions. Explore new pathways. Take a walk down a road you never have. Paint with a different medium. Sing a crazy unforgettable song. Dance like everyone is watching! God loves when we trust him like this.

Living Without Fear

Fear paralyzes you. It creeps through your mind and robs you of peace. When fear makes itself known in our lives, it automatically shuts down creativity because it is a destructive force. Some may say that there is a healthy fear. I disagree. Discernment and the need to be cautious is wisdom. Fear often puts on a mask and presents itself as wisdom, but the two are very different indeed. Wisdom leads to life. Fear leads to death. How do we know the difference? Fear is a nag - it never shuts up - never goes away until you make it leave. Wisdom is like a welcoming friend. It invites you in and asks you to have a conversation. Reacting to fear will cause you to make a mess of things. Wisdom will always lead you to beauty. This shows up in our creative walk. If we make things out of fear - perhaps that we need to produce so that we will not be impoverished or in such a way that we will not displease others - the things made are not true creative works. They are manufactured knock-offs. They have no life in them. If we create out of a place of wisdom - where we have a conversation and a relationship with the work itself, then the creative work will have life. It will be authentically present in the moment, not insecure of the future.

Our creative journeys require living fully as we are created to be. It takes believing in ourselves. My favorite life-leading quote is this by Marianne

Williamson: "Our deepest fear is not that we are inadequate. Our deepest fear is that we are powerful beyond measure. It is our light, not our darkness that most frightens us. We ask ourselves, 'Who am I to be brilliant, gorgeous, talented, fabulous?' Actually, who are you not to be? You are a child of God. Your playing small does not serve the world. There is nothing enlightened about shrinking so that other people won't feel insecure around you. We are all meant to shine, as children do. We were born to make manifest the glory of God that is within us. It's not just in some of us; it's in everyone. And as we let our own light shine, we unconsciously give other people permission to do the same. As we are liberated from our own fear, our presence automatically liberates others."

Dream Yourself Awake

Fear causes us to hide from our dreams. It causes us to feel as though our consciousness is in a slumber. I encourage you to wake up to the loveliness of a life fully awake. How might we do that? There is a synergy that awaits you when you let go of the fear and simply dream of all that awaits you. Jesus came to give us a life of abundance. He came to set us free for freedom. Dreaming takes you into the place of your manifest reality so that you can truly live in a creative life. A creative life is not just about being creative - it is about actively taking part with Holy

Spirit, seeing creative action bring you into actualized places of your existence.

Dream big. God wants you to. There is truth to be found when we let go of our own rules and restrictions about who we are and what our world consists of. Push the boundaries and dream for the beautiful impossible things you want. God has made a treasure box for you full of everything he designed for you. All the things in that box are good things. He never plans bad things for us. The scriptures tell us of the love the Father has for us. He is not one that gives you a stone when you ask for bread. He is not one that puts you in difficult situations to teach you a lesson. He loves you and wants to connect you with the dream of a beautiful creative existence.

Have you forgotten your dreams? Search deeply here. Slow down. Lay down this book and ask Holy Spirit to reveal to you if there are dreams that you once believed but have now forgotten or simply let go of. The words on this page will wait for you. Go ahead, lay the book down, close your eyes and ask for remembrance.

In the place of recovered dreams, the Lord will meet you with a great synergy and power to help you reconnect if you desire it. He loves that you would dig in the treasure box until you found that long-lost desire. Push away any thoughts of being incapable, or too old, or that it is an impossibility. It's a dream.

Treat it as so. Peer into the existence that is now in your vision and ask the Lord to unfold the reality of it. He will. Trust this. God wants to give you good gifts! The vision you have now is a good gift.

This envisioning may be like creating a life that you don't really have. You have the resurrection power of Christ inside you. You have Holy Spirit within you to guide you. The very Creator of everything resides in you and you within him so therefore you can, with God, create your own reality. If you can perceive it, you can have it. This is faith. It is the evidence of the things you only previously hoped for. Hope. Now say what you believe. Speak the positive things you perceived when you hoped. Our words have power to manifest a dreamed reality into existence. And it is God's good will to give you this. Peace, goodwill to all the earth. Will you accept his good will toward you? Will you actively believe his dream for you?

Our creative works actually manifest the dreams of God into our existence. When we work through the process of a painting, or a song, or a poem, we are actually tangibly working things out into our very existence. When we move creatively, we are not only doing something with the creativity that God has given in the form of talent. We are actually creating a reality moment by moment as it unfolds. When we put words to paper in a poem, we are pulling the thoughts of heaven into our realm. Yes, we have been given that power and that commissioning.

A friend of mine told me a beautiful story that demonstrates this. It was time for her to be wed - a young woman full of hope giving herself to a man whom she would trust for all her life. Her experience growing up had not always made her know that she could trust the men in her life. She came to her wedding day with her natural dad and her step dad and a dear uncle who had been like a grandfather to her. She thought of her uncle as a truly *grand* father because he had loved her so dearly. She did not know how to choose between her natural father and her step-father to give her away on her wedding day, so she chose neither and gave herself to her husband. In that scene of chosen independence, her dear uncle said to her new groom, "Now, you better take care of my girl." Her groom knew of his bride's close relationship to the uncle so he kept those words as a charge to him.

A few years after the marriage, the bride's uncle died. Her aunt decided she wanted to give her husband's wedding ring to my friend's husband so that the love circle would continue to live. My friend's husband accepted, of course. He remembered the words to take care of the uncle's girl who was now his. He wore the ring for nearly thirty years and all the while, the ring grew tighter and tighter. It was becoming apparent that the ring was going to have to be cut away to get it off his finger. My friend was so worried about the ring being cut because inside, there was an inscription that her aunt had made of

her initials and her uncle's initials. She could not bear the thought of the inscription being damaged, however it was apparent that the ring needed to be removed soon.

She sat at home one day writing very expressively-stepping into a place of experiential writing like never before. She began to write her story of the ring and she felt as though she was literally stepping back in time even to her childhood and looking at all the significance that the ring held. She finally came to a place where it was as if she was face to face with God and he asked her if she could trust him with the ring. She fully felt in that moment of creative immersion that she could, so she said to the Lord that she did.

Her husband had went out to do some errands and while he was out he decided to have the ring removed from his swollen finger. She did not know he was planning this for that day but he came in with the ring in a small clear bag and handed it to her. She was first awe-struck, almost gasping at the thought that he had already done it, then as she took the ring out to see the inscription that she had not seen in years, she saw that, by a miracle, they had cut it in the perfect space and that the inscription was still intact. She could even have it put back together if she wanted. She cried as the overwhelming knowing came that at the moment she was telling God that she trusted him with it was the same moment when

her husband was having it cut. Her husband had an indention in his finger from wearing the ring all those years. It was like a victory mark. He had done well with the charge his young bride's grand-father-uncle had given to him. He had taken good care of his girl. The ring was not needed as a reminder any longer. The character of the uncle's love for his girl was literally ingrained on his soul. It was like wisdom tied around his finger.

We can trust the Lord in the dreaming place to bring us into our fully awakened places. Creative action is a large part of that trusting. Without creativity, we only stay in our heads about matters. We often can only process knowledge and facts but the Lord has a better place for us. He wants us to have a knowing that goes deeper - that dips into the realm of the core of our soul, every cavern of our heart, in the spaces of our minds, and helps us to live in the Spirit. Holy Spirit calls to the depth of who we are when we simply surrender to the dreaming place of creative action. So, how might you dream through a painting, a dance, a song? How might you escape from the natural reality that binds you and take a journey artfully into the depths of his reality for you. It is a beautiful place.

8

KNOWING YOURSELF
AND YOUR GOD

There is a life to be lived that is deeper than the norm. Most people do not know themselves and do not really know their God. We settle for surfaces that appear to be who we are. We like religious boxes that create a God we can handle. There is something richer to be had. Now, let me be clear. The artful life is not one of navel gazing - selfishly over-analyzing ourselves and annoying everyone around us with our self-observation, self-diagnosis, and self absorption. However, to be an effective artist, you must know who you are and what it is you passionately express. Artists leave their mark on the world. It is inevitable. When you tap into the true artist within yourself, you will have a message. It may be a message of sheer beauty or it may be very pointed. Nevertheless, you are known by your art. What will you be known for?

Obstacles

Knowing yourself is not an easy task. There are all kinds of obstacles that come into play. We have wounds that cause us to lie to ourselves. We have other people's voices in our heads. We have insecurity and lack of confidence to deal with. Our journey is always moving out in front of us before we actually have our footing. We are constantly changing and evolving into something new. We can get scared, or tired, or lazy, or simply sick of the search. I could go on and on about all the obstacles along our path, but I'd rather be productive and focus on how you may know yourself better.

Getting Lost

First of all, I'd like to say that sometimes the best way to find yourself is to get lost. This may look like taking an unplanned vacation to get away with no agenda. It may be quitting your job to explore the unknown until you find what it is you are suppose to be. On a sad note, getting lost can be that difficult journey when you've come to the end of yourself and you have nothing left in life but to search for the true you. As we set out to know the "real me" we are actually, at the core of things, seeking for wholeness. We know innately that their is a more whole version of ourselves. Wholeness and healing are surely needed, and seem worthy to be gone after, but often we have to let wholeness simply find us. Our job is

to be open. Healing and wholeness are often quite serendipitous. God knows how to get us to the layers of who we are so that we arrive exactly where we need to be at the right timing.

Creativity can be a wonderful tool for knowing oneself. Abstract action painter, Jackson Pollock, said, "Painting is self-discovery. Every good artist paints what he is." I specialize in teaching people how to be very open to the connection with the Spirit in their creative process. This is another way of getting lost while all along being found. There is a well known quote by an unknown author that says, "If you don't get lost, there's a chance you may never be found." We never have to search for God, he always searches for us. His eyes are always longing for those who are devoted to him. (2 Chr.16:9) Surrendering your creative actions to him is a devotion. He will honor it and come close to you. When he comes close, he always reveals to us who we are and who he is. He strengthens us. This power of connecting to God through creativity is kingdom action. His kingdom is filled with those who know who they are and who their God is. The kingdom is not only for us to serve. The kingdom is where we know who we are in relationship to the King.

Knowing yourself requires intimacy. Knowing yourself is not about intellectual definition of who you are. Rather, it is about knowing your own rhythm, your own loves, the way you think and feel

and create. God loves the development of your personality. Knowing yourself is a soul-process. Remember, Jesus came to save the soul not to eradicate it. Pay attention to the idiosyncrasies that make up who you are. Purpose to know yourself. Individuality rises out of the soul like water out of a deep well. Spring up, oh well. Know yourself. The power of who you are designed to be comes from knowing the special soul of you.

When we see a divine light burning in people - that thing we call charisma - we can gather that it is because that person truly knows who she is. She is certainly on the journey still of knowing who she is becoming, but the part of herself that she has become intimately acquainted with is shining, therefore we enjoy the light and life that she exudes. This charisma leads to unity with others. It is an attractive quality that causes people to come to the light of our dawning. See, knowing yourself is such a vital element for life. It is a principle that the more intimate you can become with yourself, the more intimate you can become with someone else. God desires that we connect. It takes an artful under-standing to do this richly and deeply.

Love Yourself

To truly know ourselves, we must know our heart. The Psalmist, David, continually asked God to examine his heart. He said, "Test me, O LORD, and

try me, examine my heart and my mind." (Psalm 26:2) David knew he did not know all that was in his heart and as he judged his own actions, he knew that the things there were probably not all good. He knew how to surrender that to God. In that knowing and choosing to love himself anyway, he said, "Create in me a pure heart, O God, and renew a steadfast spirit within me." (Psalm 51:10) He chose to love himself enough to ask for divine help.

When we love ourselves even in our own imperfections and can be comfortable enough to really live in our own heart-space, no matter what its condition, then we will expect good things for our lives. We will then treat ourselves and expect others to treat us with love and respect. You are the best example of how everyone else should love you, so love yourself well. Nurture your own soul. Treat yourself kindly. Relish in your creativity.

We must not expect others to show us our greatness. We must know our own greatness and invite others to celebrate with us. This is not arrogance or pride. It actually is the opposite of that. Pride and arrogance demand attention. Knowing your God-given glory is a gift to others and yourself. In this mode, we can all celebrate who we each are uniquely and collectively. This is a very different model than finding someone to love us and affirm us, which are strivings that are in direct opposition to the artful life. Most of the world lives that way. Be different!

What Makes You Happy?

Our traditional Christian self-sacrificing culture can train us to believe that the quest for happiness is selfish. Actually, it is not. Unhappy people are not much service to anyone and are very poor representations of the Christian life. We should take joy in joy. What turns on the lights for you? What makes you smile? Who causes you to feel inspired and uplifted when you are around them? Where do you like to be? These are clues for living an artful life. Granted, our life can be difficult at times, and there are times that we must push through the uncomfortable seasons in hopes for the restored or renewed happiness, but if we keep happiness as an ultimate goal, we will find our way much more easily. Structures and rules do not serve us as well as following the visceral knowing of happiness.

Rather than being a person who does what makes us happy, we often live within the constraints of who society defines us to be. The norms of culture places restrictions on us that bind us into shadows of who we are meant to be. We are boxed in by our gender, race, age, appearance, religion, intellect, social status, financial worth, and geographical background. We are judged by friends, family, co-workers, people we go to church with, our neighbors. This is unfair but still a reality. It is up to us whether we will live by others' definitions or if we will be free to find our own happiness.

These definitions put upon us by others can regulate who we are and the things we choose to do. Do what you want to do. Say what you want to say. There is power in simply choosing what you will and will not have in your life. You have a right to be happy without others judgements or affirmations. If you love live music, then venture out to listen to it. If bright crazy colors make you happy, then wear them with confidence. The point here is in order to be happy, you must boldly do what makes you happy. Wear what you want, listen to what you like, live how you love, create out of those happy places and do it all boldly. Be confident to shine the happiness that is you. Be happy!

Harmony Within

Mahatma Gandhi said, "Happiness is when what you think, what you say, and what you do are in harmony." We must have our body, soul, mind and spirit connected in order to be the fully manifest person we are suppose to be. This is easier said than done. There are a thousand reasons why we can be disjointed. Harm done to our emotional heart can keep us from knowing the trueness of our spirit. Analytical decisions made in the mind may rob the soul of honest interconnectedness. Our words often become habitual and do not resonate with our mind or heart. We need to be made whole. May we seek alignment with God so that our mind, soul, heart and spirit will speak with a clear voice. May we move

creatively with that unity. The goal is to have all parts resonating at the same frequency - to be whole. Opening to the possibility that this can be the real you is the first step to being authentic.

We must not suppress any of our authenticity. We should allow ourselves to simply be in the wandering place while we are yet seeking for the integration of all our parts and seasons. We must have grace with ourselves. We are a vessel being formed. We can only be the honest person we are today - in this moment, in this season. There is something wonderful that happens when we have this grace for ourselves. We find that each disjointed part will begin to align with that expression of honesty and we will find ourselves coming into more of the knowing of who we are. We will see the alignment of body, soul, mind and spirit happening. We can't make it happen. We have to allow it to happen. All we can do is keep showing up to the shining place, ready to be fully who we are in the moment - present in the now.

Creative Process

Creative actions like doodling, dreaming on purpose, journaling, writing poetry, and singing your own song can help you to know yourself better. Creativity is a healer, an informer, and a guide. It is a celebrator of one's identity. It woos us into a beautiful life. It gives us place to express and shine. It is a great friend. It tells and retells our unique life-stories. The

power of the creative process always astounds me. Even the most simplistic artistic process can help us get in tune with ourself and step into a new place in our ever-evolving story.

I've led people in simple artistic processes that require little time and effort, but result in major life changes. At a healing symposium of about a hundred people, I softly asked them to still their hearts and get in touch with a negative memory from their life in which they needed healing. After the two-minute focus, I asked them to write the negative memory onto a paper and when everyone was finished writing, I asked them to either fold or tear up the paper in a way that felt right for them to be able to put the memory away from their present life. The room rattled with a hundred papers folding and ripping. The sound was kind of like the sound of refreshing rain. They were experiencing the washing.

Next I asked them to take a white tissue I had provided to them and put it to their face so that they could get in touch with the softness. I asked them to think of all the times they had used a tissue for comfort in wiping away tears. I knew that this was a relatable element that almost everyone would understand. While they put the tissue to their face, I asked them to ask Holy Spirit to come and manifest himself as Comforter to them especially concerning this negative thing they had just remembered. After a moment of meditation on the

comfort of the Holy Spirit, I asked them to place the torn or folded papers inside the tissue and fold up the tissue. Again, the soft rumble of papers dropping into tissues blended with quiet weeping throughout the room. The creative process was working to bring the needed healing. Holy Spirit was given space to move. He was welcomed by the creative process.

At the end, I had them to wrap their tissue bundle with a thread that I had given them in order to seal off the process. Many had powerful testimonies about being able to see the memory in a different light and to be able to let go of past trauma in ways they never had before. One woman said for the first time since her divorce many years previous, she was truly set free from specific areas of trauma that had still held her back. She continued to share that she now felt, after doing that simply creative act, as though she could love herself in a new way. Creativity had helped her know her true self again. Art does not have to be complex. I simply used paper and pen, a tissue and thread. Sometimes we complicate things too much.

Your Expression through Doodling

We all have a unique doodling style that is as much our own as our fingerprint, signature, and appearance. In mentoring artists, I have each one doodling every day in order to stay connected with their

creative journey. There are no rules about the doodling except that they would not set out to draw anything intentional. They are simply to put the pen to the paper and start drawing. In that process, with their body, they release the language of their hearts, minds and spirits. They find themselves in these doodles. Swirls back and forth show the searching for meaning. Boxes inside boxes show their feelings of confinement. Zig-zags show a frustrated path. Images become meaningful symbols. The simple act of putting some lines on paper in a very naive and intentionally simplistic way unlocks for them the rhythm of their hearts, the messages they are desperately needing to say, and the story that is unfolding. I've seen amazing things happen time and time again through this simple devotion. Artists find that they can see clearly their frustration, their heart-cries, and their need for answers. They also find that as they 'speak' to God through their visual language that he begins to speak back to them. The doodles become prophetic messages from God. They also find that their realities change as they draw out their current knowledge of themselves. Creativity is not just something we do. It has power to create something new. As my clients diligently work through doodling their unique expressions onto their sketchbooks, they are working out their own contemplations, and they are also tangibly shifting the atmosphere within themselves and their lives. The visual proclamations they make on the paper have power to bring change.

Self Expression

My youngest daughter, Timicia, was always so expressive as a little child. From age two, she would venture to her clothing drawers several times a day and pull out whatever she felt like wearing. She would make the best expressive outfits, always mismatched, bright and colorful. She would walk into the room looking sly and almost holding in her giggles because she knew she was showing off a new creation. She was shining. She had never been told she couldn't or shouldn't. We praised her creativity and she was in love with every expressive moment of her self. Oh, that we could keep that love for our own self-expressions all our lives! There is a link of making some adornment for our selves as children that gets transferred even as adults into the drawings and paintings we make, the songs we sing, all the things we create. Children find themselves by expressing themselves. It is a natural way we usually allow children to explore but then sadly at some point we cut off the permission. There is power found in that naive process for becoming who we need to be. The power source does not subside as we get older - we simply stop tapping into it.

Self-expression is an important part of knowing yourself - it is vital for living a satisfied awakened life. Everyone of us are meant to shine forth with the divine nature that resides in each of us as children of God. We were made to live and be

known in our unique design - it shows the very glory of God when we are expressive about who we are. Even the most introverted person wants to be known. Suppression of our creative nature, hiding everything inside or not even tapping it to know what is there, leads to depression. Since depression is actually a putting under of the self, recovery of the creative self through self-expression will actually catapult one out of depression and bring him into a beautiful existence.

We must not be afraid of our own self-expression, worrying what others will think of it or worrying that even we will not love it when we see it in tangible form. We must be easy on ourselves and remember to love ourselves. The process of self-expression is so much more important than the product. I believe God loves when we sing outlandishly in the shower even if it is off-key. I believe he loves for us to close a door and dance out loud. Expression is expression even if it is private. When the time comes to share our self-expression we need to walk into the room of life with the same confidence as my three-year-old daughter when she walked into the room in her crazy beautiful outfits. We must be bold. That's what scares us. We've been taught in a thousand ways that boldness is not acceptable. We have always been taught to tone it down and be quiet. Bold is not always unlovely or unacceptable. This is the lesson most of us need to learn.

Transparency

Transparency is a beautiful quality. Being real just as you are is endearing. In the process of showing your transparency on your way to authenticity, you must realize that even the struggles are a place of shining. To show who you are, where you are, and to show the *you* that you are right now in this present moment is powerful. There is a beauty that radiates when we can walk gracefully just as we are in the present space, faults and all.

We are an ever-evolving work of art. In the place of transition, we can show those on the outside of our process that we are not so different from them. This empowers everyone. It actually makes a demonstration of God's power through us. Transparency serves us well, because the translucency of that process actually allows us to see clearly into our journey. As we transparently move from season to season, we find out what does not bring us peace or serve us well. We need to give ourselves permission to transparently express those places.

When you sing lyrics of pain or look at a wounded memory on a sketchpad, it is difficult to ignore. If we keep all our stuff hidden in a dark closet and give it no expression, it will literally become the proverbial skeleton in the closet that will haunt us and keep us from fully living. See, the Father longs for you to be whole. He didn't put you here to suffer.

The uncovering and awareness of every weakness in you is for the purpose of growth, not defeat. The key to moving into more growth is self-expression. Growth looks like art. The alternative is usually destruction. I truly believe that without art, we resort to destruction. May we no longer choose available closets of alcohol, codependency, drugs, sex, manipulation, neediness, and a plethora of other negative scenarios to hide our skeletons. May we step into the light and shine! May we create art. May we journey artfully. Our very lives depend on it.

Knowing God

The journey of knowing ourselves actually makes our souls open up to the capacity to know God. Knowing God is such a broad realm. The traditional disciplines such as reading the scriptures, prayer, fasting, devotion and fellowship are effective for knowing God. He reveals himself in all those ways if we let them be deep teachers. However, I would caution about utilizing these disciplines as a rote way of living. We can be good at keeping religious regulations and never truly know our Creator in an intimate way. When I speak of knowing God, I'm speaking of knowing him intimately.

In the scriptures of John 4, we read about Jesus coming upon a woman at a well. He asked her for water but she met him with sarcasm and a spew about rules and regulations - things that had never

given her life. She saw herself as less than and it was expressed in her bitter talk. She was bitter. Her life had not been one of ease. She really didn't know herself very well and it had caused her to fall into the arms of one man after another until now she was an outcast. She argued with him when all he had asked for was a drink of water. Something about him provoked her.

He told her about a different water that he could give to her if she wanted it. She, in almost a challenging way, asked him for the water. She was sure to add that she would like to never come to that particular well to draw water again. The well was a gathering place for the women of the village so it was a source of pain for her to come there every day since she was an outcast. All the women knew her too well. Jesus asked her to call for her husband and come back to the well and she made a lame answer about not having a husband. He told her simply that she had previously had five husbands and the one she was with now was not her own. We gather from the scriptures that she saw the living water Jesus was offering to her in a new light. Her eyes were opened and she saw that he was the Messiah. She was drinking the living water.

The most interesting part of this encounter that I take from the scriptures is that she, right away, ran to her village and told them all to come meet a man who told her everything she ever did - who told her

about herself. From our reading of the scripture, Jesus did not tell her everything about herself. He simply made one statement about her marital status. So what happened that day? I believe that Jesus looked at her and spoke to her in a way, that in the core of who she was, she knew that she was known. She, for the first time ever, could see herself in his eyes and rather than seeing the outcast that she had become, she saw herself as one who was accepted by God. She saw who she really was, so she could see who he really was. She understood the living water was freely given and that it was her very salvation. We must know Jesus that way. We must know that with every moment we can have him like a fresh drink of water. We have an opportunity to drink of that living water. He wants to unclog our wells, help us know our true selves, so that we can taste the living water too.

Deep Knowing

Knowing God through a creative life is a diving-deep experience. It takes us below the surface of rote Christian discipline and shallow understanding bringing us into the deep well of the living water. God is Creator, so to connect with him and learn of him through creative action and living, aligns us with the most essential aspect of his nature. As we align with him in this way, I believe it will be the very life-source that allows us to understand all the other parts of his nature. The nature of God is fathomless

and he invites us to come through the door of creativity so that we may have the fullness of the kingdom - the fullness of him.

The Door

Jesus is the door to the kingdom. He opened the door for us to have abundant life. That abundant life does not only include creativity as a piece for us to receive, but creativity is actually the door provided. Jesus' finished work of the cross and resurrection was to bring us back into oneness with God - back into the creative synergy with him, where we carry his very life-breath. The life-breath that made us a living being was a creative breath. Our very living nature is so linked with creativity, that it literally is essential to connect with God. It is my hope that we will become more and more aware that the door to the kingdom is creativity in Christ and his creativity in us.

Creativity is Life

Creativity is life abundant. The very nature of the word creativity is life coming into existence. The opposite of life is death. The opposite of creativity is destruction. We cannot have life without creativity. To try is futile. We can look at destructive lifestyles and see that they are void of pure creativity. Pure creativity only comes through the connection with Holy Spirit. Many artists touch pure creativity but

reject the power and then find themselves most miserable. If you have touched life and will not hold to it, then destruction quickly comes.

There is a cure for destruction. The cure is the creative life found in Christ. This is why I love creativity so much - it has the very real experience of leading us into pure expression and encounter with God. One gone astray from the love of God can be called back into his goodness by the power of creativity. How many stories have we heard about a song completely shifting a person's life, a painting class helping someone recover from alcoholism, dance being used to become a vehicle for positive expression rather than destructive behavior. Creativity is a good tool to give life and light in the atmosphere of darkness.

Destruction can look like our typical understanding of immorality and carelessness or it can look like religiousity. One is as destructive as the other. A very common thing that happens to creativity is that it is reduced to using it as a tool to enforce religious dogmas. This is an assault on creativity. It does not give life but produces a death to our very spirituality by turning our intimate relationship with God into a set of rules and regulations. Creativity should be guarded from this kind of religious abuse. If it does not have the potential to bring us into a closer, more intimate, relationship with God, then true creativity is not present.

9

CREATIVE THOUGHT AND ABUNDANCE

The desires God placed in you are valid. Dreams become realities. It is possible, as one who chooses rhythm over rote and grace over work, to move with God toward the stuff of your dreams. Your creative life can be fabulous, effective, and successful. God is wanting to give us all that we have need of and so much more. John 10:10 tells us that Jesus came to give us an abundant life. Do you believe?

Energy

"For by Him all things were created that are in Heaven and that are on earth, visible and invisible. He is before all things, and in Him all things consist (exist or are sustained)." (Colossians 1:16) God has made us to be spirit-beings. We are energy and

movement. Our energy is one with our bodies, souls, minds and spirits. It is the very thing that makes us alive. It is the breath of God in us. Our energy can be thought of as our personality, belief system, attitude, and being. Energy is very connected to thought and as I mentioned previously, as a man thinks, so is he. What are your thoughts about yourself? How do you feel? By tapping consciously into how you feel, you can evaluate your energy. Is your energy creatively awakened or are you desensitized in some way? How well do you know your own current energy? It's as simple as asking yourself how you feel.

An artful life is regimen and medicine for living a life full of the positive energy of being exactly who you have been designed to be. This is our ultimate purpose - to fulfill the design Creator has ordained for us. He is the source of all goodness. He is the source of all original design. His breath breathes through us, which is the actual energy of our lives - the stuff that makes us ourselves. We must connect to the Source of all Goodness and feel the Creator's breath in our lungs, minds, spirits, souls, language, thoughts, and bodies. Tap in to the Giver of Life - the Giver of Energy.

You are designed by God to have a unique energy about you that is like no one else's energy. When we are off our game, feeling tired or frustrated, we will say that we don't have any energy - that we are tired

of things being the way they are. These are clues that we are not being our authentic selves. Each of us is dynamic in a very special way. We must know ourselves - our unique energy - and express it. Living an artful life requires that we make an expression of our unique energy. It is simply you being gloriously you! To be yourself you must know yourself and then take a leap of faith and become the best version of you that you can be.

There is a scripture that talks about us being in the world but not of the world. This relates to our energy. See, the world system is full of ways to rob us of our authentic energy. We must remind ourselves that we are spirit beings, not robots of our current cultural system. Our societal structures, from education to economics, government and religion are designed from human striving and based on mechanics of control and manipulation. We must learn to live fluid and free from these conforming systems. It is not easy to do, but small steps toward living in such a way that does not conform to someone else's required boxes is a good start.

Intentionally tapping into creativity is the most direct way we can connect with the Giver of Energy. We may think first of worship or prayer as the way of connection, and those practices are actually very creative. Worship is the highest form of creativity. The most wonderful thing is that there are unfathomable ways of worshipping. The lifting of

the hand taps us into the energy of the spiritual flow. Sitting silently in honorable contemplation expands the mind into the mystery of the wonders of creation and the Creator. True worship is always creative.

Creative Thought

Tapping into your God-designed energy takes focus. It is important to be creatively intentional about getting in tune with your unique and authentic energy. What you think on will manifest. Your perception has power. It has been said that perception is always true because in our minds the perception we have is all we can truly see. Until our focus shifts, all we have is our perception. If we feel drained of energy, if we feel fatigued and tired in life, then perhaps our perception is off. We must refocus our attention on the things that are true. Who does Creator say he has created you to be? It is important here to not focus our attention on the things we do - the things to which we will give our energy - the "to-do lists" that we can get busy with. It's imperative that we focus on who we are, not what we are to do. There is great power in simply being. All of our doing should come from our being.

Your energy focus will influence your creative expression. When you create something into tangible form, there is power therein. The atmosphere of your life and the landscape around you shifts

because of your energetic creative expression. Your energy manifests itself into your life. Be sure your thoughts and your actions - your nature and your art align with one another. Do you find that you love whimsy? Is the expression of your life and specifically your creative expression whimsical? Are you a deep thinker? Is your art contemplative causing others to experience deep thoughts? Your energy dictates your creative expression. Some are so dead to their own energy that their creative expression is non-existent. It is very common when we are worn down, burned out, or tired in life - lacking energy - that we experience creative block. They are linked. There is a real tie in our energy level - our ability to be fully who we are - and our creative expression. How do we become unblocked? Focus on energy.

Encourage Your Heart

To increase our positive energy we are invited to focus our hearts on the Energy Giver - the Life Breather. David, a man after God's own heart, encouraged himself in the Lord. He encouraged his own heart to open up to positivity. There is great value in opening your heart up to the One who gives goodness. It is about surrendering. He is always ready to flood our hearts with His Goodness. Simply encourage your heart. A friend said to me, as she was talking about how difficult it was to believe positive things for her creativity and life, "Well, you know, we

are all our own worst enemy, right?" She proceeded to talk on about why things were not working for her and I stopped her and said, "Wait! We can't be our own worst enemy. We have to be our own best friend." This stopped her in her tracks as she looked at me questionably. I went on to tell her that we need to talk to ourselves as though we are our very own best friend. Why would we agree to be our own worst enemy? We have to be with ourselves all the time, so I'd prefer to be nice to me.

I often encourage myself in the Lord. I look at where I am and I think about what would a really great friend say to me and then I begin to speak to myself that way. I say things like, "Pattie, now you have learned this lesson before and you are wise about this. You are strong and kind. You have the Lord with you and he will direct you in all your ways. You know the voice of the Lord, and you will make good choices because you are smart and kind and loving." I go on until it becomes very real to me and I believe again the encouragement I'm hearing from my own lips.

So often, when we are discouraged, we think that we have to press into prayer until we hear the word from the Lord that will zap us out of our problem. We over-spiritualize things. If we don't get direction from God in those moments we feel let down. If we do, we feel like we have to fulfill "the word," and also, we will often question if we really heard from

the Lord. This can give us a complicated mess that we really could solve if we would just learn to encourage ourselves and believe that God has good things for us and that we are worthy of his goodness. Knowing and even memorizing encouraging scriptures will build up your ability to encourage yourself in the Lord. Psalm 116, "Be at rest once more, oh my soul, for the Lord has been so good to you" is one of my favorite scriptures. We must tell our soul how to respond sometimes. We must be an encourager to our own soul.

We do not have to fight a battle in order to regain energy. Fighting depletes our energy. What we fight, we give our energy to, so rather than fighting, try surrendering. Encourage yourself. Light always casts out darkness. The Lightbearer is always trying to rush in and brighten our lives. Open the door and let the light in. He wants to illuminate you with new energy. New energy for creating more energy. See, it's the process of nature that light multiplies, creates, makes things to grow. Spiritual principles always mirror natural principles. How can you open the door to let light shine in?

Forgiveness

Sometimes our hearts may not be ready to accept the goodness of God. There are many reasons for this, but one of the things that robs of us our energy more quickly than anything is a heart that is

unforgiving. Unforgiven grievances cause a hard veneer to form over the ears and eyes of our hearts. Simply deciding to forgive, even if the decision is shallow initially, cracks that veneer. Forgiveness is a strange process. It seems we have no control over the length and layers. We simply have to keep showing up to that place of surrender, offering our hearts to the hammer of unconditional love. Forgiveness doesn't usually change the hurtful things of the past. The forgiving process requires us to actually surrender our stubborn belief that things in the past should have been different. This surrender of hope is the thing that actually allows us to let go of what was not - to let go of the grievance. When we have stepped into that place of surrendering the lost expectation, we realize that everything has a gift hidden in it. Forgiveness turns the negative circumstance into a positive energy for growth. When we can step through the corridor of forgiveness and actually be thankful for the horrible things that gave us opportunity to grow, then we are free. Forgiveness will ultimately bring us to the place where we can be grateful that everything we've been through has taught us how to be who we are today. That is positive energy that will rocket itself into manifest creative expression.

Faith

God is attracted to our faith-filled thoughts, decisions, and actions. When you put out a belief

proclamation, all of Heaven will chase you down to get the reality of that thing to you. The things you imagine, then see, then proclaim, especially through the proclamation of creative expression, will manifest in your life. It is so important to feel the feelings you want to feel. Dream beautiful dreams. Put a creative plan into place based on what you can believe. Speak positively. Treat yourself the way you want to be treated. What you put out about what you believe for your life will come back to you. Sow good seeds of faith into the good land of a positive life. What do you have in your hand that you can use to start a journey toward the positive things you want to see in your life? There is something so powerful about taking risky first steps to move into your dreams. God loves for you to trust him. The things you imagine, then see, then proclaim - especially through creative expression - will manifest in your life.

Preconditioned Understanding

Many of us are slaves to our preconditioned under-standing. If we have always suffered lack, then we will believe that is normal. If everyone in our families and immediate relationships have always treated us with dishonor, then we will expect more dishonor. We need our minds illuminated. We can be illuminated by divine revelation, yet illumination also comes to us just by purposing to live artfully. Read new books and see the world and life from

different perspectives. Listen to music you would not normally choose so that you may find new experiences there. Go to museums. Visit the theater. Find new friends that are different than you. I could expound in many directions about being illuminated so that you might recondition your thinking. If we only ever look in our own box, we will never experience the treasure of diversity.

Believing the Dream

What are your dreams? As we explore the passing thoughts of our hopes, we will define the wholeness of our dreams. Hurts and trials in life can weigh on you so heavily that hope can seem impossible or irrelevant. We can also get so very independent, seeing our own efforts as the way to our dreams, that we forget about hoping and we only are busy with goal-setting and striving. Hope is extremely important. We should meditate on our hopes continually and actually believe the things we hope for will come to pass. Hope mixed with creative action will cause dreams to manifest. So if we can muster up even small amounts of hope a little at a time, it will move you closer to your dream. Emily Dickenson said it so wonderfully:

> "Hope is the thing with feathers
> That perches in the soul
> And sings the tune without the words
> And never stops at all."

Aristotle said, "Hope is a waking dream." I'm going to give you a simple exercise here that will help step you into your waking dream. It begins very simply by saying your hopes aloud. You will simply start with, "I hope _____ (fill in the blank.) Your statements can be as broad as, "I hope for world peace" to as small as "I hope I hear my favorite song today." You may think this is silly as you begin but by the time you have said a few hope statements, you should feel a tangible hope arising in your spirit. The hope will flood in and your statements will come more quickly, be more meaningful and focused and you will notice that there is faith being attached to them. This is the stuff of dreams. You are actually hoping your way into knowing and seeing your dream come true. Journal about this experience, writing down what you hoped for and how your feelings changed. Do this often so that your heart will not become sick from hope deferred.

Feelings, Thought, and Action

In my experience of helping artists step into their dreams, I have some great testimonies of various ways people have broken through and started to see favor for their artistic journey. Almost all of the success stories have required creative action. Creative action is not always easy and if it is done without the process of exploring our paradigms of thought and feeling, then the action can be ineffective and even detrimental. Knowing this principle, I almost always

start with a client that comes to me for help by exploring what they think and feel about their creative journey. Feelings are one process and thoughts are another. They often overlap as we usually cannot clearly distinguish what we think from what we feel. There has to be an alignment, a working together, of feelings, thoughts, and actions. This alignment paired with wise decisions is like the fairy dust of dreams. It is when we see dreams become actualized in our lives. Heaven wants to effectively show itself in the natural realm. God has promised us the abundant life. We must partner with those promises.

I was on a call with an artist who had a dream to move forward with her creative journey. I asked her to tell me her dream without any holding back. She said she would really love to have a studio of her own and a place where other creatives could join her for small gatherings and creative days. I then asked her what was preventing her from having that. She began to speak in a downcast tone that it was just impossible right now because she and her husband lived in a small apartment and there was no extra financial provision to rent a studio. I asked her, "What do you have in your hand right now that you could do that would help you to press into this thing that you want?" She was silent, then an, "I don't know." I said, "Well, have you thought of how you would like this studio to look?" She said, "Yes, oh yes!" I heard her hope rise. I asked, "Have you

started collecting photos and ideas for the studio?" She said, "No - I had not thought to do that." I spoke to her about how starting a dream folder of ideas and photos was something that she could actually do right now. Her feelings, thoughts, and action was coming together. She made a decision that she would do that. Only a few days later she reported back how things were going. She had started her dream folder. She went to church that weekend and her pastor's wife came to her and said, "We've been noticing what God is doing with you in the arts and we want to encourage you by offering a building that is here on campus to you for your art studio." She was elated. Furthermore, the pastor's wife told her the building needed some construction work and that if she had an idea about what she would like for the studio, they would have the construction crew make it to her liking. Did she have any ideas? Yes - she had a folder full of them! She is now in her art studio and has started gathering other creatives to be with her. This is an awesome testimony of a quick turnaround of bringing together feelings, thoughts, and creative action. You can have this too. Start a dream folder for your dream. Imagine what you want.

Visualization

The dream folder is an example of visualizing what it is you want to see and most of all it is about getting the picture of what God sees for you. There

are endless ways that you can visualize for your creative journey. When you take what is previously only in your mind and heart and begin to bring it into the tangible world, miracles can happen. Creating a painting, writing a poem, or dancing your dream are creative ways to visualize. Remember that any creative action carries the power to actually create! Dream boards can be created by cutting images from magazines that link to things you would like to have in your life and arranging them onto a simple poster board. This is not only a way for you work out how to structure your life, but it helps you to get a picture for what you want to have, and it actually tangibly creates these things in your life. Another type of visualization is simply asking God to give you an image in your mind's eye in response to a prayer focus. Accepting the clear picture and attaching your faith to that will cause the favor of the Lord to be released to you and you will see it come forth in your life. If you want positive things to occur, then first try seeing them, then feeling that joy, then making up your mind that you will have it, and lastly, make some creative expression to activate it into being. Do this all with wisdom and the leading of Holy Spirit. It's not a magic trick. You must ask the Lord for guidance.

You are Waiting on You

Many of us are waiting on someone or something to come and save us. Our fairytale stories of childhood

have given us false ideas about expecting more from others than we should. We are always Cinderella waiting for the prince and Snow White waiting for the kiss that will bring us back into life. Jesus has already given us everything we need for life. He is the Prince Charming. He is the kiss of life. If we are in him and he is in us, then we have everything we need already. We simply need to learn how to access it. We are the one that is usually the obstacle in our own way. We have wounds and mindsets and even real circumstances that keep us from believing for the best. Rather than waiting for someone to save you, try believing that you are the one you are waiting for, then step up and arrive. It simply takes you, because God is already there in the place you want to be.

10

THE POWER OF
AN ARTFUL LIFE

Our creative expressions are purposed to actually carry the power of God. Paul said to the Corinthians, "My message and my preaching were not with wise and persuasive words, but with a demonstration of the Spirit's power, so that your faith might not rest on human wisdom, but on God's power." (1 Corinthians 2:4) Paul knew the difference in delivering a sermon and delivering a demonstration of power. When he spoke of Jesus as healer, he saw healing take place. When he spoke of Jesus as deliverer, he saw deliverance. He purposed to share love and peace, not just talk about it. He was not there to convince people. He ministered in such a way so that power might be released in his presence. Our creative works - our music, dance, visual art, drama, writing and media - should be presented with

a demonstration of power like that. When we move with the Spirit, we will move in power. We are not absent from that process, rather, we must be very present in that release of power. The miraculous release of power we read of Paul experiencing in Acts 19:11 did not come by him doing nothing. He was active. Paul had to open his mouth and speak. He had to stand up in front of people. We are not a robot that God controls. We are not merely a vessel to be poured. We are co-laborers with God. God expects us to show up and be ready to partner with him. He has given each of us a unique voice and calling that we get to link up with Holy Spirit to see our own unique view of the power of God.

Imagery & Intent

Often, we, as "Christian Artists" can get caught up in the idea that our art must speak about the powerful things of God - the *big* ideas of our Christian faith. We think that in order for our art to be powerful, we must paint or write or sing overtly about themes such as the cross, salvation, Holy Spirit's touch, the love of the Father, redemption, grace, and our list can go on and on. We believe that the most powerful expressions must involve our typically recognized Christian imagery like doves, lions, crosses, angels, and the like. Though I have at times seen these images used in powerful ways, and do not discount them entirely, most of the time,

especially in the genre of prophetic or worship art, they are simply used as props to express something *about* God, rather than making an expression *with* God. God wants to speak through all imagery. Everything can be sacred. If we remind ourselves that everything can bring us into sacred space with him, then we will no longer distinguish acceptable "Christian images" from non-acceptable secular images. Jesus used common bread made with human hands to speak of himself. Why do we, in our religious prejudice, disregard so many things?

The integrity of intent in any form of art is a vital starting point for demonstrating power. If the intent is merely to make a beautiful expression, then your subject must be something in which you are enraptured by its beauty. If the intent is to make a statement, then if done well, the statement will be made. As artists, we must do as Jesus did - do and say what the Father is doing - and truly create out of our God-ordained nature. If the intent of your work is to convey movement, then you must move. If the intent is to tell a story, then you must know the intricate message of that story - it must be alive in your imagination. If the intent is to sway someone's thinking, then you must have a passionate faith in your point of view. If the Father moves upon you to create for the purpose of healing, then healing should be your sole intention. If you feel an overwhelming sense of love in the place of the Spirit, then paint with a release of that love.

There is a difference in merely telling about something and actually demonstrating the thing you want to convey. I could paint an illustrative picture of the blind man being healed so that you would have the knowledge of the story. This could be useful to your understanding of the story and it may even build up your faith to believe for healing. However, I could connect with Jesus as Healer and bring a demonstration of healing power through the painting - I could paint until I felt the faith for healing and may even feel a release of healing in the Spirit or even tangibly through my hands and onto the canvas. That painting may look very much like the previously mentioned one, or it may be entirely different, but the process is different - the intent is different - the anointing is different - the faith level is different. If I can connect with Jesus as Healer, and have faith that he wants to release healing through my creative expression, knowing that he is in me and I am in him, I then have confidence to paint in a way that releases his manifest healing through my hands to the canvas. The canvas itself can be a carrier of healing much like the handkerchiefs and aprons were that went out from Paul's body to bring healing to many. (Acts 19:12) There is tangible power released when we create. This is a demonstration of power. This is what God wants to do through all creativity. He wants to show himself in all his glorious demonstration. Our creativity is an avenue for Jesus, the hope of glory, to bring his heavenly kingdom into the earth.

Your Unique Demonstration

To bring a demonstration of power, your creative expression must come out of who you are designed by God to be. He knew you before the foundations of the world were lain. (Ephesians 1:4) He even knit you together in your mother's womb and knew your complete frame before you came into this world. (Psalm 139:13) He knew your story before the beginning and he knows its eternal passage. There is nothing hidden from him. He knows all the creative things you will do. He has designed, especially for you, an unfathomable series of sacred spaces to encounter. The demonstration of power that you are ordained to release will come out of that unique design of who you are. Your unique expression of God's power has been birthed in you even as you were conceived in the mind of God, even as he knit your form in the beginning. Will you open your eyes and ears, and the spaces of your soul and spirit to catch the vision? Will you answer the call to revolutionize your own awareness?

I have a friend who is a prophetic painter. She creates lovely pieces that show the soft movement and flow of the Spirit. Her abstracts seem to flow out of the canvas as liquid colors blend together creating ethereal atmospheric works of art that speak from the Spirit to the spirit. She came to a point in her work that she wanted to move into

other subject matter, rather than only abstracts. She wrestled with this for a while, trying several different types of subject matter until she finally painted a huge peony. The peony was so powerful. Its color, form, and movement literally radiated beauty and growth off the canvas. The peony seemed to be alive. It was a demonstration of power. So, what made this painting of a flower so powerful? My friend is a gardner. She loves to tend flowers. She knows their intricacies, their patterns and subtleties. She painted the peony with her understanding of that flower mixed with her understanding of flowing with Holy Spirit and the dynamic - the power - was evident. Growing flowers is a sweet joy for her and a place of connection with the Creator. So, when she painted the larger-than-life peony, that unique connection and her design as a gardner and a painter came together in a synergy that was full of life. Her work changed from there on, because she had glimpsed glory in a way that was a unique expression of God through her.

The Importance of Voice

As artists desiring to translate the glory of God into our atmospheres, we must first have something to say – something that is extraordinary, moving, and relevant to ears itching for the revelation of the great mystery. We must say it well. We must sing this new song beautifully. We must capture and embrace – grabbing the heart, soul, and spirit in non-typical

ways. We must say things in a beautifully powerful way. In a world that bores easily, we must enrapture the unexpectant ears and eyes of those passing through our circles. We have an opportunity to answer the questioning hearts and sing into the ears of those who are not even aware of their listening. We have within our untapped repertoires the masterpieces that may define a culture - if we find and speak our voice.

Voice is everything in the Arts. Good art always transforms in some way. If there is no marked response from a viewer – a hearer – then the art has been ineffective. Sometimes the ineffectiveness is due to the lack of interest or understanding of the recipient, however, herein is our first challenge: how do we interest or provoke the questions of our culture so that people will take notice to what we have to say? We can blame others for lack of care and understanding. We can become cynical about the culture, the church, or those close to us who do not understand us as artists or we can rise to the challenge of every artist – to cause someone to look, listen, care – to change the world with art.

I speak of a transformation where the world will care about art that reveals the Divine. The transformation will not come through our typical Christian ways. The world is tired of hearing chatter that is empty and lifeless. The world is tired of hearing a song that has been sung a million times about our boxes and lists of rules, forms, and

regulations. The world is asking questions and we must put down our preconceived ideas to sincerely listen to what is being asked. A key element in finding your artistic voice is to ask yourself who is listening and what questions are they asking. In other words, who is your audience? Who are you serving with your voice? If you want to be effective, you must know to whom you are speaking.

The Uncovering of Your Story

Often, our art is a process of our own self-discovery and our discovery of God. Our art answers our own questions. We are our own audience. We, as creatives, often work out our salvation – our struggles and triumphs and our understanding of God through creative processes – through language we can understand. The personal language we acquire in our own journey can be relevantly translated through our unique creative works in an endearing, sensitive and sincere way – in a way that is all our own – in a way that is original.

Your process looks like nothing else the world has ever seen. It is unique to you. Your language and unique understanding of the way you do life and the way you connect with God is a masterpiece. Your process is authentic. Your voice that comes out of your own journey is compelling. Your story is important. The images, sounds, colors, movements, and words coming out of your own organic life-process are the raw elements for achieving voice in

your art. What things do you love? What do you notice in life that others overlook? What makes you feel close to the divine nature of God? Surrender your process to God and He will give you much to say as a creative. Discover what color Holy Spirit paints through you when you are in sorrow. Find what His joy looks like through your piano composition. Search out the movement of prayer through dance. Sculpt the very questions of existence with clay. Write your sincere fragments of thought - the words that are only pieces of questions and ponderings. Listen. Listen for His response. Hear His Voice intermingling with yours. He has given you your very own story.

Sharing Your Story with Transparency

As our creative experience and language develops we may find that we want to expand our audience and share our story with others. Our journey can be interesting and helpful to others. There is a commonality that joins us. If spoken with transparency, your artistic voice can be a great testimony of God's power and grace. I encourage you to allow people to see the real you – the you that struggles with the artistic elements; the questions of your own heart; the raw stuff that cannot hide when you create. If we can sincerely and compassionately show, through art, our own life struggles, our own reaching for the divine, and our own triumphant finding of Him, or I should say, "His finding of us," then people may listen because ears are listening to

hear that someone is experiencing the same journey. All hearts are searching for God.

Paul - The Creative

Paul was for a long time on the wrong track concerning being who he truly was. His name was Saul while he was caught up in religious zeal that caused him to reject Christ and take part in slaying the early followers of Christ. He, like King Saul of the old testament, was haughty and selfishly ambitious to the point of cruelty. He later called himself the "chief of all sinners" to express how badly he had missed God during those times. However, Saul had an intense encounter with Jesus, and he was changed to Paul, the one who revolutionized the ancient world by preaching the Gospel of Jesus throughout. Paul was one of the most influential apostles and pastors of the early church. His teaching and letters to the church, which make up a large portion of our New Testament scriptures, became words that, for centuries, believers have abided in, journeyed through, and used as a covering of protection for living out our journey of faith.

Now, Paul was also a creative one. Paul was a tentmaker. He was a storyteller and a dramatist. See, I believe that Paul's tent-making - his creative livelihood - informed his preaching and his interaction with the early church. I think he met with

God when he made tents. Likely, the tents were made of leather or goats' hair. I'm sure that as he pieced together the materials, he thought of the way the early church was coming together. As he handled the animal skins, I'm sure he thought of the sacrifice Jesus made for sin. As he went about the task of designing a dwelling, certainly the Father spoke to him about creating spiritual coverings for the new converts. Tents were made to provide shelter as people would move from place to place. I believe Paul felt a connection to his creations as he realized that as he went moving from place to place to preach the Gospel, the Father provided for him. See, our creativity is not to be separate from our life - our ministry. Creativity is to be in the all of life.

Paul was a storyteller. When he came to Mars Hill, (Acts 17) he didn't use his old tactics of presenting the do's and don'ts of the law to the people. He knew the powerlessness of that method. Instead, he found a place to relate to them. He noticed their altar to "The Unknown God." and he began to tell them a story of who that God was. He creatively wove a story from their place of understanding to convey truth to them in a powerful and effective way. Because he knew Jesus and Jesus knew him, Paul could speak to them of the power of knowing God - of the Known God. When Paul was given space to speak to King Agrippa, he brought out the storytelling creativity. As you read those scriptures in Acts 26, imagining Paul delivering his story, there is

no way you can picture it without seeing Paul move around, using his hands and body to convey emotion and expression. You can simply hear his voice rise and fall with the emotion of the story. Paul was a dramatist. He told such a good story - it was simply his story mixed with the story of Jesus - that King Agrippa believed that Paul had done nothing wrong and he would have likely been released had Paul not requested to go before Ceasar. Paul had felt the dramatic episodes of his life in a deep way. His conveyance of that depth came out in his story/ performance before King Agrippa. Paul knew that in him (Jesus) we live and move and have our being. He had said that very thing at Mars Hill. So, on this day, the day he was chained and imprisoned, the day when King Agrippa gave him permission to tell his story, the day when his life depended on a good story, Paul leaned into the creative power within him. He moved as he spoke, living out the story through a dramatic presentation, and rested in having his very being in Christ. Paul was a creator that day - a creator of a great story and performance that got into the hearts of King Agrippa and the others that were with him.

Peter - The Creative Fisherman

Peter was a fisherman. I love how the very first encounter Jesus had with Peter was in Peter's fishing boat. From the beginning, Jesus let Peter know he

loved who he was and he wanted to bless who he was. He told Peter in that first encounter that he would take the gifting he had for fishing and use it in spiritually rewarding ways. He told him he would make him a fisher of men. Surely, Peter's gift of fishing - that creative place - came into play many times as Peter sought out to bring people into the kingdom through salvation. I imagine just as he knew how to cast a net into the right place in the water to catch fish, he also later knew when to throw out the net of salvation to a group of people who were ready to take hold of the goodness of the kingdom. Peter never had to abandon who he was to become something else, as many will teach. He didn't trade being a fisherman for being an apostle. He simply changed nets.

After Peter had rejected Jesus during the time of Jesus' arrest, trial and crucifixion, he carried so much shame that he had lost a sense of who he truly was - and in his mind, he had especially lost who he was to Jesus. They had been great friends before Peter's rejection. After Jesus' resurrection there is a scene in John where Peter says he is going fishing and he asks the other apostles to go with him. This is the night before they meet Jesus the next morning on the shore. Some teachers say that this was Peter going back to his own self-sufficiency - his old way before he knew Jesus. I say that going fishing was the best thing he could have done. It was his creative process to fish. I'm sure that as he went out in that boat that

night, he remembered how Jesus had climbed into his boat the first time he met him and preached to the people. I'm sure that night, as he looked down at the water, that he remembered how he had walked on the water to meet Jesus. Certainly, as he let down nets all night with no success, he remembered how Jesus had shown him that at his word, he could let down nets and they would be full. When he stepped back into who he was - the creative fisherman - he was brought close again to his memory of Jesus. I believe that connectivity made his heart ready for the meeting he would have on the shore with Jesus the next morning.

Peter and the apostles had been out fishing all night unsuccessfully. They come to the shore in the morning to find a man on the shore. It's Jesus and he asks them if they have caught anything. When they tell them they hadn't, he told them to cast their nets back into the water and when they did the nets became so full that they could not pull them in. Peter had seen this before. It had happened almost exactly like that when Jesus had called him to come be his apostle. Peter was reminded again of who he was, this time by Jesus himself. All the provision was there to catch many fish. Peter was still who he was, despite the mistake. Jesus was cooking fish for them over a fire. This fire was much like the fire that Peter was warming himself at in the courtyard on the night that he said he didn't know Jesus - on the night he rejected his friend and Lord. When Peter saw

Jesus cooking over the fire, did he remember the coldness of his rejection? I believe that he did, however, when Jesus asked them to bring some of the fish they had just caught, Peter was eager to get the massive net and haul it into shore. He knew the power of that catch. He understood the provision Jesus was giving. Jesus already had fish cooking, but I believe he wanted to bring Peter into his calling again. He wanted him to connect with his design as a fisherman so that he could once again understand his creative calling - his passion to catch men for the kingdom.

In this time on the shore, Jesus and Peter connect again - heart to heart. Jesus longs to be our friend, our brother. Jesus asks Peter, "Do you love me?" The greek word used here is the word *agape* - which is "perfect God-like love." Peter responds, "I love you." The word for love which Peter uses is the greek work *philio* - which means "the love of a friend, a brother." Again, Jesus asks Peter the same, using the word *agape* and Peter responds as before with the word *philio*. Each time, Jesus responds to Peter's *philio* response with, "Feed my sheep" telling Peter to take care of those who would come to Christ. The third time Jesus asks Peter in a different way if he loves him. He says, "Peter, do you love me?" yet, this time, he uses the same word Peter had used, *philio*. Jesus asks Peter if he loves him like a friend, like a brother. See this time, Jesus is being deeply relational with Peter. By changing the word

for love, Jesus is saying, "I know you like a friend, like a brother, and I want you to love me that way. I don't just have for you a high and lofty love of *a* god - I'm not just asking you to love me *as* God. I know you Peter - do you love me in that way - do you love me in that knowing place? In his asking Peter to love him in this relational way, he is calling to Peter in a way that let's Peter know that he values him for who he is, not just for his adoration or service to him. He is calling deeply to Peter to be who he is and love people from that place - to feed his sheep. Jesus does the same for us. Who are you truly? Serve him out of that place. It will, like with Peter, bring a demonstration of the power and love of God through your life.

Artful Heritage and Inheritance

"For we are to God the pleasing aroma of Christ..." (2 Corinthians 2:15) The fragrance of Christ coming from your life has a unique aroma. He desires to make himself known in powerful ways to you and through you. The Father knew who he made you to be, where he planted you in the earth, the family and community he gave you to, and even though he may not have controlled all the things that have happened in your life, he knew and knows every tiny detail of it. Our heritage is part of our creative demonstration of God's power in us. Nothing is wasted. We need to press into the wisdom of our heritage. We are to appreciate where

we have come from. It's all our story - and your story, when surrendered to the Lord, is powerful. It's all for his glory - yes, all - the good, the bad, and the ugly. God values every detail of your past, present, and future. Your heritage and inheritance is important to him. Because it is important to Father Creator, every part is an element for creative processing and creative expression.

Drink the Water Where You Came From

There's a song I love by Kings of Leon called *Radioactive*. The lyrics are:

> It's in the water, It's in the story
> of where you came from
> Your sons and daughters in all their glory;
> it's gonna save her
> And when they dance and come together,
> and start rising
> Just drink the water where you came from

I'm from deep in the Appalachian Mountains, from a small little region called Southwest Virginia, which is comprised of nineteen counties in the south-western tip of Virginia. Though the counties are now experiencing some revitalization and heritage appreciation, it was not that way when I was growing up. I was always a little ashamed of where I was from. As a child and a teenager, I dreamed of going off to the city - perhaps New York City or Paris and

living in a cool loft apartment and having nothing more to do with my mountain ways. Thankfully, I changed my mindset and in the past several years, I have learned to love my mountain heritage more than any city dream I could conjure up. I still love the city, but I adore the mountains. It has been a deep spiritual understanding for me to realize that Appalachia is in my bones - and that God has beautiful things he wants to do through me because of those deep roots.

When I ponder that the Lord's voice is like many waters, my spiritual ears remember the sounds of the creek by my house when I was growing up and how refreshing it sounded mixed with giggles and little screams as my sister and I and my childhood friends would catch crawdads. I also think of taking empty milk jugs to the mountain spring to get fresh water with my daddy. The sounds of those jugs beating together as we would go up the stream bank sounded like drums that I often hear in my spirit during worship. When I think about how God knit me together in my mother's womb, I think about how my mom taught me to sew pieces of fabric together to make dresses for my dolls when I was only four years old. The creativity of those mountain moments find their way into my spiritual walk and my creative journey. Nothing - nothing is separate from our creativity. What are the things you remember from your childhood? Stop now and remember them.

My Pappaw and Mammaw Baldwin were creative people. Pappaw. a preacher, made shoes and hand-tinted black and white photographs with water-colors. Mammaw made plaster *what-nots* and was a seamstress. She had her own little shop. I look back over my creative life and I see how their influence is in my blood naturally and also how their creativity flows into my life spiritually. Years ago, I designed clothing - made most of my own quirky artistic clothes as a teenager, and later in my twenties, I had a children's boutique where I made custom clothing. I'm named after my Mammaw Annie. She would have liked that dress shop.

May I share with you how watching my Mammaw Annie make figurines from plaster influences my art in a powerful way? When I was a child, Mammaw would let me help her with pouring the molds with plaster, removing the figurines, sanding them and painting them. I loved that time with her and with my cousins. I hadn't thought of that in a long time until I started sculpting my figurative sculptures. Those sculptures are some of the most powerful statements I've made with my art. They are very deep and metaphorical, provoking responses from viewers. I believe they carry a deep rootsy power that is an expression that I could only deliver because of my rootsy upbringing in Appalachia, which time with my Mammaw in her *what-not* studio, and sometimes her kitchen, was a big part. I could go on and on about the prophetic influence of my grandparents'

creativity: I minister and tell stories like my Pappaw, I build metaphorical shoes of creativity for people to walk in like my Pappaw made natural shoes. I hope to bring color into people's life through my creative outflow like the way he made the color to flow onto the black and white portraits of his time. See, the heritage of those gone on before us is a deep creative well which springs up into our spiritual walk if we will only value them as sacred.

My Pappaw Whited was a coal-miner, as was my daddy, so when I think about my proud heritage of being a coal-miner's daughter and juxtapose that against the devastation of mountain-top removal that is happening in Appalachia now - well, I have to make an expression of that. Many of my art-pieces have been pieces that not only bring an awareness about mountain-top removal to the viewer, but the process of them help me to powerfully demonstrate God's heart for his creation.

My Mammaw Whited made quilts when I was a child. We slept under her quilts and ran barefoot through the grass underneath them when they would hang out on the clothes-line. Those are some of my best child-hood memories. I can remember the ones of patch-worked ladies, each one dressed in a different color and pattern holding colorful umbrellas. The butterfly quilts were my favorite. My Mammaw was a bit grumpy, always scolding us for something we were doing wrong as we played out in

our yard on the hill above her house, but I remember how she was like a different woman when she was making quilts. Often she would get me to help her with the quilts: tracing the patterns onto the fabric, pinning them, and cutting them out so that she could embroider them onto her quilt blocks. I remember feeling so valued as an artist even then, because contrary to her normal grumpiness, when we quilted, she would praise me for the exact tracing and the steady cutting that I did. She let me into her world of creativity - her small world of beauty.

Heritage begins with those closest to you. You may think that there is no creativity in your family, but you must search for it. Search in the unusual places and ask Holy Spirit to inform your artful journey with the heritage that has gone before you. We are all connected - take a look at the ones who are close. Art has a way of making itself known in people's lives. It wants to be present. Honor it by searching it out in your heritage and ask how it may inform who you are as an artist in this season.

11

THE SOULFUL & SPIRITUAL LIFE OF COMMUNITY

Spiritual life requires focus and intentionality, yet it is not something to be done heroically. Spirit is not based in the ego, which requires that we gather our best skill set, willpower, strength and effort and make a display of our excellence. No, the spiritual life is actually based in its relationship to the deep well of the soul. The spirit, which is perfected in Christ does not need any refining. It is the soul that needs the touch of Holy Spirit. His waterfalls wash and flood deeply into the well of who we are. This is the artful life - fully soulful and fully spiritual. Thomas Moore in *Care of the Soul* says, "The soul needs spirit, but our spirituality also needs soul - deep intelligence, a sensitivity to the symbolic and metaphoric life, genuine community, and attachment to the world."

The Soul and the Spirit Connection

Your unique soulful way is made up of your experiences, beliefs, idiosyncrasies, upbringing, culture and your rhythm for living. It's also made up of the gutted out emptiness and waiting seasons of nothingness between the big experiences. All of life shapes you. None of it is for naught. One of the greatest beauties of the artful life is that people who are courageous enough to live it live in such a uniquely beautiful way, giving the all of who they are to the all of life that is presently upon them. The inner wonder they embrace pours out into all their life. Everything becomes sacred in an intentional connection to the divine.

There is sacredness in the ordinary. Our Christian structures make things too complex. There is a simplicity that brings us very close to the heart of God. To quote from my book, Sacred Revolution - The Power of God in the Arts:

> "When we can build the bridge between the everyday common occurrences of life and the holy experiences we have in church and religious activity, seeing them all as sacred, then we will understand more rightly the heart of God to come close to us right in the midst of our very common humanity. We will then

experience more deeply the Incarn-
ation. We will know Emmanuel - God
with us. Artful sensitivity is a door to
that understanding.

The soul and the spirit are not at war with one
another. Their unity actually provides a strong
weapon against all that comes to harm. The artful
life provides space for the unifying connection of
the soul and spirit, which effects the mind, emotions,
the heart and even the body. The atmosphere within
our soul is invited to shift to the atmosphere of the
spirit through the divine connection to Holy Spirit.
This experience provides opportunity for others to
live collectively with you on your journey. There is a
beautiful synergy when that collective journey finds
creative expression. Let me explain by telling you of
a painting I did during worship called, "The
Atmosphere is Shifting."

The painting started with a cloudy sky and a high
horizon line of dark blue indigo mountains. I
painted this because it was the mood I was in. When
I look at an abstract landscape, it is a mirror to me.
The horizon line was as if I was looking at the
mountains running through my chest and the sky
was around my head. My head felt cloudy and a bit
stormy. So as I painted the mountains, I began to let
a purply gray color stream down the canvas in drips
from the mountains. If the mountains where at the
level of my chest then everything underneath those

mountains represented the core of my soul. The purply gray is a healing color for me, so as the color ran down the canvas, I felt the healing run into my soul. It felt very soulful though I sensed the deep work of Holy Spirit calling to my spirit as well. This sensation was clearly moving from the heavenly realm into the earthly realm - the earth realm of me. As I painted, I began to feel elated by the worship in the room and in my heart, and so I began to paint a bright cloud breaking through the dark stormy sky. As the bright clouds came bursting through the dark atmosphere, I felt my mood shifting. I also felt the atmosphere in the room shifting. I painted the light down into the mountains in thin lines and began to paint small white openings in the underground soul region. White-yellow light was emerging.

About this time in the worship, prophetic song began to emerge and the music was building and building into an explosive place. I put down my brush and palette and began to dance interpretively. I was swooping my arms from one side of my body as if gathering something and motioning in such a way as to be throwing something down on the other side of me. I did this very low, which usually represents a deep intercession. As I did this over and over, my arms rose higher and higher. The music built up more intensely and I began to aggressively throw my arms above me from one side to the other as if there was a violent breakthrough shift happening. I sang softly, "Awaken the breakthrough.

Awaken the breakthrough." Without hearing me, the lead singer began to belt out, "The atmosphere is shifting. The atmosphere is shifting!" I immediately grabbed my large 3" brush, crashed it into the lime yellow on my palette, and swiped it down the center of the 'soul' area of the canvas. The room erupted in worship and there we were - in the middle of the atmosphere shift. The music, the movement, the song, the colorful image, the exuberance of the worshippers - everything together agreed and testified in the *now* word of God to us. His manifest presence had come. Holy Spirit had called to my spirit which brought my soul into unity with the divine. In that experience, I walked soulfully in the everyday sacredness of knowing my atmosphere was shifting. We collectively experienced the shift.

Living Soulfully with Others

The bird a nest, the spider a web, man friendship. This line by William Blake speaks simply and deeply to our need for home. Home is not only found in the physical environment we live in, but it also speaks of those whom we spend our lives with. We have a deep craving to feel at home, and friendship, as Blake so quaintly expressed, is made to provide it. Friendship is a beautiful part of every good relation-ship. Marriages, partnerships, relationships with our children, parents, sisters, brothers, friends, and extended family - all these need to have friendship at the core of their existence. It is true that we are

placed in certain relationships that seem to happen without our choice. We can trust God that he cares for our souls well enough to let us be where we are suppose to be in the right timing. We must trust that our soul shows up in the present moment with those who are there around us so that we can learn the lessons to be learned, move on as needed, and stay attached to those friendships that last and serve us and the other person well. This takes a lot of trust to live that way, yet it is the artful way.

As we shift and change relationally to the people in our lives, it is so vital that we allow the soul and spirit to move as it should, meandering through the joys and difficulties that relationships bring. We can manipulatively try to make our relationships fit our own agendas so that they are functional rather than truly fruitful. When we handle relationships with our own selfish regulations, rules, rigid boundaries and functionality, then we are setting ourselves up for a life void of soul, which leaves us with a life void of the true meaning of art. Art itself opens the soul to realize that there is a better way to live in connection with others. There is a way that is rich and meaningful. The way is not easier. Actually, it is much more difficult, because it requires staying with the process, making sacrifices when necessary, trusting the other person with your heart, and very much patience. Out of this soul/spirit movement comes a rich rewarding life that will bring depth that most people do not find.

The Power of Conversation

Conversation is an art. We should personally study the nuances of our own power in conversation. How do you relate to others? How can you give yourself to others through the art of conversation? You have something to say that no one else does and you say it in such a way like no one else. This is beautiful and it is a gift to those who find themselves in your presence. Spending time in conversation is crucial to our development. Many studies have been done about the power of conversation for developing infants' ability to understand complex language structures at an earlier age. I'm not simply referring to baby talk. As parents and carers build conversations with babies and young children around the things that are going on in their everyday world, children become more complex, growing in intelligence, and becoming more creative. We've lost the value of conversation. Great conversation helps us with the development of our creative lives. It's time to recover that.

Perception is a gift in which we can view the world from a chosen perspective. We often only see our own perception and in that, we can believe we are the only holder of truth. It can be a constricting kind of box to only have one perception. This is where conversation steps in to help us. As we openly share our perceptions in an atmosphere of honor, we will see that our minds open more to others and

we grow. Simply sharing your thoughts helps to stretch you into new ways of thinking. We step into a higher intelligence, a deeper creativity, and a richer, more meaningful life. Your voice is a catalyst for forward movement. Talk to someone.

So how do we cultivate conversation? We must first start with valuing it - wanting to actually hear what others have to say. We should look at conversation as a way to connect with the other person/people, not fill our need for company, affirmation, or ego. Charm is over-rated. Snobbery is passe. May our conversations focus on learning about the beauty the other person has to share.

With that desire to learn from others, we can guide our everyday moments into conversations. It only takes a focus to do so and things will arise to talk about. We can talk to those core people in our lives, our outer circle of friends, even strangers. Start with a question and simply see where it leads you. To make a conversation rich, you can intentionally lead it into deep explorations that give you rich varied things to talk about or you may stay on the surface and keep it very abstract and purposefully not precise. The most refined thing about the art of conversation is that you take cues from the other people involved and gear the conversations to give them space to share. This makes the other person feel valued, which will make them love having conversations with you. If done with genuine

interest and respect, there is nothing manipulative with this. It is a good way to love and honor people. This type of honor will always open doors for divine leading so that the conversation not only progresses in a natural way but that Holy Spirit is invited into the process. We do not always have to intentionally invite God into our conversations. He is already there. We just need to move gracefully with one another so that we can be aware of his presence every moment.

Creative Relationships

We need creativity to be core in our relationships because creativity has the power to give life. We must let creativity do its transforming and evolving work. Forming relationships is like raising a garden. We need to know that the soil of our life and the soil of the life we are connecting with has the potential to bring a harvest. We need to know how to plant good seeds, weed out harmful things, protect from predators and care for all the things that grow to bring us life.

We naturally gravitate to those who are kindred spirits. It is rich and rewarding to find someone in life who understands our language and seems to understand our rhythm. These connections are gifts from God - we should pay attention to cultivate life with those people, caring for one another creatively. There is a synergy that happens with creative people.

My hope would be that we, as those tapped into our creative nature, would shine that into the lives of those who are not tapped in and that out of that connection, creativity would be birthed more and more for everyone. However, though that is the hope, I do understand that does not happen with everyone. May we have compassion when it does not and yet press into the goodness being offered when it does. It is a gift when we connect with others on a creative plane. It does cause other relationships to pale. We must hold love as our guidepost with those we are kindred with and those we are not. If we hold love in the place of honor, expecting it to find us and bring transformation, it will show up more in our lives. Love is always chasing after us. When we are open to receive it in whatever way it arrives, always knowing that it carries the nature of true beauty, it will come in and nurture our souls.

Trueness of Community

To have an authentic community experience, you must be honest with the people to whom you are connected. You also must be honest *about* them. Trueness spawns a rich community experience. Ask yourself some questions about the people in your life. Why do you enjoy them? Why are they in your life? Do they fill you with positivity? If there is friction or discord, what is its purpose? How are we learning to love well in the difficult relationships? You have the right to have the kind of people you

would like to have in your life. We should give this some thought. Of course, we are never given the right to be arrogant or choose people based on selfish desires. We should never manipulate circumstances, but we can purposefully set out to have certain creative types in our lives. There are some essential relational needs, that when we see the void of them, it actually causes us to understand our need. We do know what kind of people bring us joy and make us feel alive and we should value that. If we are sensitive to our need for friendship, and ask the Father to bring that person into our lives, I believe he will.

For example, I notice that I can be indecisive and have an excessive mercy at times so I've prayed for an older woman as a friend that would speak very directly to me. God gave me that person. I need friends that make me laugh and can be lighthearted when I need to pull up out of deep thought and have a good time. I know who those friends are. I have friends that will tell me like it is, those who inspire me to think poetically, those who challenge me to have faith. I have an understanding of the voice each of my relationships have in my life. They are an extension of me. I am not a solo person on my own journey. We are all journeying together.

It's important to know what our tapestry together looks like. I continually look at my relationships and evaluate the season we find ourselves in and how our

togetherness may be evolving. I make alterations as needed based on the synergy or the void. It's important to not box another person into your definition and not to allow anyone to box you into theirs, remaining in the flowing place that allows people to be different things to us at different seasons is part of the unfolding artful life.

There are those people in your life that are many things to you and you are many things to them. These are the relationships that are at the core of your life. The closest relationships, especially like marriage, children, siblings, parents, and best friends, are multi-faceted and sometimes can be the most confusing. We have to give space to those people to shift and move in and out of their various roles according to our needs. We must give ourselves freedom to shift and move according to their needs as well.

The people whom we deeply love speak into the layers of who we are. These are the relationships that last, and that even if years or space separate you, their voice will always remain in your life. The greatest gifts in life are those people who simply *stay*. They do not leave because the purpose shifts. They do not go away because there is difficulty. They remain connected at the core while everything else fades and comes into definition. These are our soul mates. We have many. Keep them.

12

GRACE FOR THE
ARTFUL LIFE

Flannery O'Conner said, "There is something in us, as storytellers and as listeners to stories, that demands the redemptive act, that demands that what falls at least be offered the chance to be restored." Artful living restores. Creativity redeems. Life has a way of tearing us through. At some point in our lives we will face major disappointments, hurts, losses. In those times what are we to do? We can choose to stop living fully. We can choose to bury the pain and allow the creative block to set in. We can shut out art or we can look at pain in the face and make art of it.

The Light

We must always look to the light, but often we cannot truly understand the light unless we look

squarely in the face of darkness and hope for light to be had there. When light shines in darkness, we realize how beautiful the light really is. Creativity offers us a way to see the beauty rather than just dumbly staring into the overwhelming darkness. Confucius said, "It is better to light one small candle than to curse the darkness." Artistic action lights candles in the darkness of our lives.

Embracing art in the midst of difficult times can benefit you in so many ways. It can give you a place where you can release your emotions, work though your issues, and press into wholeness and resolve. Furthermore, the artistic process allows you to create something positive in the midst of problems. It allows you to get in tune with the way you feel and actually bring redemption through your art. See, you are a light-bearer, so where you go, light will come. You carry the creative DNA of the Creator, so where you go, you bring creative activity.

Grace

The artful life is a grace-filled life. Grace is provided to us by the finished work of Christ. We don't only partially have grace, rather, if we are in Christ and he is in us, then we are fully covered. We are fully redeemed. We are fully in the light and in us there is no darkness. So what does this look like in our creative process? It means that you trust the journey. You believe that you are worthy to receive all that

God has for you creatively because you are covered by grace and that every good thing will come to you in its perfect timing. You trust that even the difficult times are for a reason and that the reason is so that you can be brought into good places.

Henri Matisse, one of the greatest painters of the 19th century, was bedridden in his latter years after a serious operation. He began to do amazing cutouts because he found it easier to work with scissors than a paintbrush. Out of his courage to believe that light would come even in the midst of his personal darkness, he found that he loved what the cutout technique did for him. He wrote to a friend that his earlier paintings "always had the feeling of too much effort." His cutout work brought him freedom and a feeling of ease. Matisse made art out of his difficulties. This is the way to live the artful life. No matter what happens, you still show up and make art. The art may change as you move through the seasons of life, and as you press into creativity you will change too. No matter what the difficulty, you still show up and keep creating. This is the key, we must keep creating.

The Inner Place

The artful life, because it is lived with an expectation for wonder, is a life that leads to intimacy. It makes one intimate with self, others and God. The peering in to the ever-unfolding life causes one to look for

the quiet places. Contemplation comes easily. A slower pace gives one room to breathe and rest, work and grow. Art unfolds from those places.

In my journey, I am continually led to the inner place with God. That space is within me and yet within God. It's a dwelling place for us both. It is a space that is alive with creative thought. Living in this inner space allows me to live peacefully and confidently in all the other outer spaces of this world. Any time I feel distant from that sweet creative place, I run back to it with fervor. It is my life-line. This inner place is available to everyone. I believe it is the intimate place of creative conception. There are so many other places of creative action: wild active places, studious places, laborious places, and birthing places, but the inner place is where creative conceptions begin and life originates from there. It is crucial that we all have that space within ourselves and with God. Without it, we are barren. Without it, we are merely imitators at best, and imposters at worst.

The Unfolding

As with a piece of art that changes and unfolds as the artist crafts it, an artful life is the same. We must learn to be so in tune with our life, hearing the cadence of it like a fine composer, knowing the rise and fall of pitch and tone. We must know, like a passionate painter, when to use a different color, how to construct a new form, the way to bring

depth. We must be intimately involved with life itself - artists creating artful lives. Our lives are the master-pieces that are now being formed and which will speak to those who come behind us. Lives lived well are legacies to remember.

God is the master of our lives and our creative works. It is a welcoming invitation and a great reward to live a life that is full of meaning. An artful life is such a gift of grace, however, grace must be accepted, received, taken hold of. As with all gifts, we must learn to be a receiver. We must be aware of the gift in front of us that is being offered. I hope that this book has inspired you to see the many gifts of an artful life and that it challenges you to take hold of it and open it up with care and joy.

Artful Living Transforms

I'll leave you with this story. There was a man who had, all his years, tried to have a good life. He looked around at others to see how they had achieved a good living. He did his best, however he learned even as a young boy how to follow the dysfunction that surrounded him. So many things presented themselves as the path for living, yet they led to death. His search continued. He tried continually to do things the right way. Live responsibly, work hard, make a good living. Do what others expect of you. Be a man. Have courage. Don't let anyone hurt you. These mantras became so ingrained in him, he

forgot the innate knowing that living is about loving and being loved. He tried in his frustration to love others, to love things, to love success, but nothing ever satisfied. He did not love himself, and sadly, this was the one truest thing he needed, yet the thing he could not grasp. Hurts and mindsets, circumstances and mistakes prevented it.

His world began to unravel because all that striving has a way of turning on itself to devour the one that hosts it. Successes faded into destruction. Relationships dissolved because truth had never been a part of them. Things that had been acquired were lost in a moment. Despair at having nothing but himself set in. He realized the one he had become was really not someone he even knew. He wondered if he had ever really known himself. The art of his life was gone. Peace, that thing we all want for living, had not been found in the things he had obsessed over. It had not been found in all his 'doing.' It had not been found even in the beauty of his family or the presence of God because peace is not found as long as only the outer shell is touched. He longed for the inner transformation - the change that would come to help him find his true self so that he could find true peace for living. He wondered if there was anything true about life at all.

He listened to the voice of one who loved him. She said, "Go fishing. That is where you find yourself." With reluctance, he did. When his feet hit that

riverbank, something familiar struck his heart. There it was again. Life. He remembered when he was eight years old and he caught that big trout. The lure he chose was perfect. The struggle to reel it in was the fight he won by his own hands and wit. The joy he experienced was his and his alone - for a moment at least. The confidence he felt could not be taken away as his little brother poked at him and his older brother cussed him. This was his gift. It was his accomplishment. It was his art.

Fishing that day led him back to the truest thing he knew. It was the true him, before the harms of life had taken their toll and before he had taken his life in his own hands to make. Simply going fishing at the river unlocked the place where God had always been. The flow of the water was Holy Spirit movement. The throw of the line was praise. The pull of the fish on the end of the line pulled on more than his hand on the reel - it tugged at his heart. God was calling. Asking him to know himself again so that he could speak to the true one he had designed. Layers began to unfold in the places that had become unraveled. The creative energy of being in nature, crafting the perfect lure, and swinging with the perfect motion caused him to catch more than a big fish that day. It caused him to re-catch himself - the one who is loved with an unfailing love.

Creativity offers a place where we have never been before. It beckons for us to experience its newness.

No one else has ever been to the exact place that your creative calling provides. God has designed for you a very specific path. That path will require that you leave the mundane comfortable places that you call life. It requires that you take risks - risks to love, lead, dream, break boundaries, be outrageously yourself and forget the old ways that do not serve you anymore. You must trust your intuition. You must trust that you know the voice of God. You may not know exactly what you are doing or even know how to be yourself in a new way of life, but you must trust. You must trust God. You must trust art. You must trust the you who longs for the something more. Life awaits you. One never knows how beautiful the dance will be until the music begins. Listen for it.

Please enjoy the first chapter of *Sacred Revolution: The Power of God in the Arts* by Pattie Ann Hale.

SACRED REVOLUTION: THE POWER OF GOD IN THE ARTS

The Calling

"To worship is to quicken the conscience by the holiness of God, to feed the mind with the truth of God, to purge the imagination by the beauty of God, to open the heart to the love of God, to devote the will to the purpose of God. All this is gathered up in that emotion which most cleanses us from selfishness because it is the most selfless of all emotions - adoration." (William Temple, former Archbishop of Canterbury)

James 4:8 - Draw near to God, and he will draw near to you...

From the Beginning

From the moment of Creation, all humanity has been called to creativity. It is the desire of God to have a creative people who would worship Him out of the core of who we are - out of the God-breathed place of our existence. He desires for us to find the core of truth that resides inside us and offer that beauty back to him in a way that brings Him glory. As he simply wanted Adam and Eve to be truly close to him, he wants you to be close to him.

In the beginning, God breathed everything into existence. He breathed and it was created. He formed Adam with his hands from the dirt, yet he breathed into him life. In that very life-breath was the crucial element of creativity which had revolutionized the void. From thereon, the breath of God, the pneuma, gives life to our mortal bodies. We, now, as live ones, carry the breath of God. We are now meant to revolutionize the void.

When Adam fell, it was as if the breath had been knocked out of him. He could not live as he had prior to his shame. Adam, though he had walked with God in the cool of the day, hid himself from Father. The communion they had was wrecked by sin. God had given Adam the exciting task of naming all the animals. Adam had been given in that first life breath the ability to understand God's exhaled intention and he gave concreteness to the

animal's existence by giving them names - by putting language to their form. Adam had partnered with God in the definition of the Creation. Yet, after the failure, Adam began the regression of all humanity from the glory of God. He and Eve hid from God and covered themselves with fig leaves. God made a sacrifice to cover them. He brought to them animal skins. It was the first killing of the creation to cover the lung-sucked shame.

In the reckoning place with their sin, Adam and Eve were given a promise that one would come to restore their closeness to the Father. Humanity was given a promise of a child that would bruise the serpent and restore all that had been lost. When Jesus came, he put on the very dirt-flesh of humanity so that he could fully restore the spirit lungs to breath again as Adam had in the beginning when God breathed life into him. The pneuma breather was to be fully alive again. Creativity was to be awakened again in its fullness. Jesus came to give us a new birth, in which a fullness of the understanding of life and the God-breathed intention of everything created would come to the forefront of our existence and our search for him. You see, Jesus did not just come to save us from ourselves in our horrid humanity. He did not only come to save our souls from hell or to only come to guard us from the enemy. He came to make us new - to give us a new mind - one that is connected with his genius - his breath. He came to restore all things.

Creativity is not something removed from certain ones and given to others. If you are alive, and especially if you are awakened to the Spirit of God, your creativity should be flourishing. Jesus died so that you may have life and have it more abundantly. The basic element of life is the creative breath. Creativity - and its expression - art - is vital to a fully-lived life. It is the normal way to truly live. Are you ready to live more fully? Breathe in.

Worship

Art in its true form and unhampered expression is so beyond our definitions. This is the calling: to redefine art as worship - to see that we are to all live artful lives - worshipful lives - unto His life-giving glory. We are made to worship. It is our life-calling.

In the way God brought Adam into alignment in the naming of the animals and the cultivation and care of the garden, so he desires for us to come into alignment with him in creative ways - for his purposes and for his glory. The Psalmist said, "Let everything that has breath praise the Lord - Let everything in the heavens and the earth praise His Holy Name." The calling to be creative is not exclusive. The calling is for all of creation to worship Him. It takes creativity to truly worship.

The Father loves to see us worship. It blesses his heart, not just because of the glory that he receives,

but because it draws us near to him - and he loves to be near to us. He yearns for the daily walk with us in the garden. He misses the place of sharing bread with us. He longs to breath with us every breath. The Palmist said, "Bless the Lord, oh my soul, and all that is within me, bless His holy name." The *all* that is within us surely never leaves out creativity since it is the very life-breath that sustains us. The creative breath of God which brings us to an abundant life in him must exhale worship or it fades into darkness - not being life-giving, but life-exhausting. Jesus came to give us life. Art is never separate from worship. Worship is never separate from art.

Sacred Space

God provides a sacred space through art. The connection to the Spirit through movement, sound, color, and light brings Heaven to earth. A dance can bring with it the tangible wind of the Spirit. A painting can reveal other-worldly images and colors. Sound from our voices and instruments can reso- nate with the frequencies of angels. Writing, stories, and drama can bypass the intellect and bring dunamis change in our souls. God wants to give us a sacred revolution. He wants to show himself powerful through the arts.

We must know that art is a sanctuary, a safe, sacred place where we can go to find God. In the very

process of exploring creativity, we find the matters of the heart and the spirit. As we enter into the creative process with Holy Spirit as a reborn, re-breathed creation, then we, like Adam in the beginning, regain an understanding of the mind of God and an intimacy with his heart. We can then give definition and concreteness to the sacred place of the Spirit. We can make the intangible tangible and we can make tangible creations which will shift the spiritual realms. This sounds like an epic happening, but let me tell you a simple story to convey how simply it can come about.

I had been painting during worship at the church we attended for a couple of years and a very creative little girl named Madison, about five years old, was always hanging around after church to look at my art and talk to me. One Sunday, I asked her if she would like to paint on the canvas and of course, she was excited to do that. I explained to her that she was to pray as she painted - to just ask God to tell her what to paint, and I left her alone for a while to play. When I came back to her about twenty minutes later, she was glowing with giddiness. She had such a great time! I asked her if she had prayed while she painted and if Jesus had said anything to her. She nodded her head enthusiastically and said, "Yes - he said I did good!" I laughed and thought how sweet of the Lord to give her confidence as an artist at that tender age. She was painting with real paint on a huge canvas - it could have been intimidating for her but

her message from the Lord was that she had been a real artist that day and that she did a good job. The message in this was enough, but it goes further.

The next Sunday, I was painting on the same canvas and I heard a specific directive from the Lord to paint around her little creation on the lower half of the canvas. I painted with the movement of Heaven as I worshipped in color, painting all around the canvas like a doorway encompassing her painting. The movement was intense as I painted. The painting, in the end, was beautiful, but visually it was a little awkward with my mature painting around her naive simplicity. However, I knew I had expressed my sacred place and Madison had expressed her sacred place, all on the same canvas, in the same space. The reward came later.

I gave the painting to Madison's grandmother as a gift. A few weeks later, she pulled me aside after church to tell me of what was happening with the painting. She had hung the painting in her living room and a friend had visited her and had suddenly called her into the living room where the painting was. She said her friend called to her with such excitement that she thought there was an emergency. When she got to the living room, her friend was standing in front of the painting and was declaring that the colors and forms were moving - dancing! She wept as she told me that she saw the painting moving too - dancing in front of her eyes and that

many people in their home had seen it since then also. The intangible movement of the Spirit realm had broken into the natural realm and God was showing his presence in their home through the piece of art. The tangible power of God was being continually released through the painting. The grandmother said it was as if the painting kept re-painting itself to minister in various ways. A sacred space had been established in their home for continual and fresh revelation. Heaven had come to earth in her living room.

Unified with the Creator

One may ask the question of how we are to use art to express our faith. In that question, we can miss the real answer. Art is not merely a tool we use to express our faith. May I propose that faith - our belief in God - and art - our means of expression - are meant to be one and the same? God has given us creativity as well as he gives us faith. They are integrated gifts to bring us close to him. To understand this, we have to broaden our typical understanding of faith and our understanding of art. We think too narrowly of both. Overall, the ultimate goal in art, creativity, faith, and life, is to be unified with the Creator. It is his ultimate desire to be close to us. He is the life released; he is the light being poured through our hands, words, songs, and movement. This journey and display are not just for the exalted demonstration of His glory - it is also for

the demonstration of his lowly great love and desire for us, his creation.

The Ache

In the hearts of us all, there is an ache for beauty, even for something beyond our current understanding of the beautiful. Some say beauty is fleeting and useless, but they still long for it. This longing, in an essential way, is the desire for a true God - a connection back to our Creator who walked with us in the cool of the day. We all have glimpses of him, some more than others, yet still there is always a reaching and wrestling within our souls to see and hear more of the divine. Art, in its various forms of expression is a way of seeking and finding the Beauty - the True Divine.

Michelangelo said, "A beautiful thing never gives so much pain as does failing to hear and see it." We not only want to know about beauty; there is within every person a longing, though it may be hidden, to see and hear the beauty of the kingdom. Jesus said repeatedly, "Do you not have eyes to see? Do you not have ears to hear?" Artists keep their eyes open and their ears listening. It is the calling of all people to be seeing and hearing in this way. We are all artists. We are all seekers of the mystery. Beethoven said, ""Don't only practice your art, but force your way into its secrets, for it and knowledge can raise men to the divine." Einstein said, "The most

beautiful thing we can experience is the mysterious - the fundamental emotion which stands at the cradle of true art and true science. He to whom this emotion is a stranger, who can no longer pause to wonder and stand rapt in awe, is as good as dead: his eyes are closed."

David, the one who was after God's heart, exclaimed, "When you said, 'Seek my face;' my heart said unto you, 'your face, LORD, will I seek.'" (Psalm 27:8). David sought God creatively in the song, the dance, the harp and the heart. He listened and saw beauty and expressed his findings in the Psalms. David was an artist. All his days, he sought the beauty of God. The ache for more beauty lasts our lifetimes, even in the presence of the finding, we still ache for more of His glory. God designed it this way. He longs for us to wrestle and search and seek and find Him. He loves our insatiable desire for drawing near. He wants us to see Him in the beauty of His holiness. He is beauty. Michelangelo said, "Many believe - and I believe - that I have been designated for this work by God. In spite of my old age, I do not want to give it up; I work out of love for God and I put all my hope in Him." Even at the end of his magnificent life, he still had the loving ache to see and hear more of God.

Here is an excerpt from my journal conveying my ache to understand Beauty and how I find it in creativity:

One thing I have desired... to behold the Beauty of the Lord. ~ Psalm 27:4

Beautiful... who can understand the making of it? Truly, who can explain the beauty of the white moon in an indigo night sky? Who can find words when you look into the minuteness of the smallest most humble field flower? Who can articulate the wonder of a fuschia-orange sky over the blue-purple mountains?

When our eyes gaze at awe, even when someone is standing right there beside us, how can we know they see as we see? How can we explain the beauty? There is no understanding unless we stand there together and speak of the exact beauty we are taking in. Still the limits are present in the reflection and only the heart can feel it and hope for a spirit-to-spirit understanding.

How can we speak of the Beauty of the Lord - of His Holiness? Shut my mouth. Hold my tongue. Exonerate my racing mind that has to prove something.

Beauty is not in the telling - it is in the observation - in the acquaintance.

This one thing I ask...

To see you in All Your Beauty would melt me... but may I get a glance?

I believe You reveal it to me when I free-sketch - the moving lines that stretch out on the paper before my pen actually flows over them. The deposits of solid revelation before I fill in the sphere. The zig-zag that moves me back and forth reflecting the way I try to find you - it shows my discord in still not living totally in that flow - still I wrestle for the figuring out of things. Set me at ease; sway me; hold me; inspire me, Beautiful One.

I bow under your solidity of Beauty. I dance in the fluidity of your Holiness.

The Expression

Because of the way the Father designed us to be in relationship with one another - to be a family - we find great satisfaction in expressing and sharing our journey-findings. Our creative endeavors, no matter how they are expressed - naively or expertly - are vital soul cries to find the beauty or to proclaim that we have seen the beauty. I believe the Father loves both - the reaching to find Him and the joyful celebration. When we have seen and heard, we must tell. Someone said, "Inspiration without expression leads to depression." It is our nature to fight against the depression. We are purposed to creatively thrive.

This is why children love to create. It is built into our nature to create as survival. Creativity takes us through rights of passage as we walk out our journey to and with God. We are all on the journey, so no one's creativity should ever be discounted and all should be celebrated. It is life.

While we seek and listen on our journey, a creative response is inescapable. We all search for beauty. Often, people who do not think of themselves as creative, will nevertheless, make a creative expression of their journey. They will talk with their hands, making telling and sometimes dramatic movements to explain their inner emotions. Their voices will rise and fall in songlike rhythms and harmony with the frustrations and joys as they talk. Even shopping can be an indirect expression of creativity. People enjoy shopping because it brings them into contact with various textures, colors, smells and different atmospheres, giving them some way of making a creative response, even if it is only in purchasing what they enjoy. How often we discount creative activity because it doesn't fit our typical boxes of how creativity is normally defined. Expression is crucial to every human being.

Creativity and artful living shows up in many ways beyond painting and making music. I know a man who loves to cook for his family when he feels close to God because it connects him with nature, savory smells, movement, and relationships with those who

God has given to him. This is his finding of divine beauty. Beauty is there in the everyday elements to make a meal. The beauty is in the faces of those he loves. I have a friend who loves to tell stories because when he does, the heart of God is expressed. Within the most common of things in his stories, a beauty is unraveled that speaks of the essence of goodness - of God - and he becomes one with the Beauty. Through storytelling, he comes into relationship with God. For those moments while he tells his stories, he walks in the garden in the cool of the day with the Father. The creative life is a rewarding life and it is a life that is close to the Father's heart.

We were designed for expression. The inner journey of the soul will always find its expressive outlet either in positive or negative ways. The absence of a positive artful expression leaves room for a degenerative expression. Negative life patterns such as addictions, obsessions, and futility are the response of choosing to not search or listen for the beauty. His grace is sufficient to always be shining brightly to show us the way to beauty - to Him. Even in the negative situations, painful or dysfunctional expressions can bring us to the awareness of our need for Him. Our whole lives, we all are on an inevitable journey of expression that directly links with our relationship to God. Even if we are unaware of the expression or its meaning, it makes itself known.

Vision

In order to live a creative life, we must see beyond boxed-in religion and embrace relationship. Jesus discounted the ways of the religious at every turn. He, in the way he drew in the sand, and made mud balls for healing, and told compelling life-giving stories, was truly a creative artful journeyer. Oh that we would catch a true vision of him and be like him. Jesus only did what he saw and heard of the Father. An unknown author has gifted us with this saying, "The religious will never understand that distant look in your eyes, for they have not seen what you have, they have not heard the voice of many waters running through their souls, but you have. It has always been the same: those who dance are thought quite mad, by those who don't hear the music. You have heard the music of heaven and your soul has been sweetened by that sound."

Creativity brings one in relationship with the Creator. This creative journey goes beyond religious understanding. It is mystery. A life lived creatively does not conform to boxes of tradition and musts and must-nots. As is revealed in the scriptures, the law has no power, it was simply a shadow of the way to approach the life that was to be revealed in Jesus. When he came, he did away with the religious boxes and gave us a way to see and hear which had not been fully understood before his coming. 1 Corinthians 15:45 states: "The first man Adam became a

living being"; the last Adam (Jesus), a life-giving spirit. Jesus - the Light - came to bring us into a beautiful life that reflects the Creator, therefore creativity is a certain characteristic of the life-giving spiritual life.

Holy revelation brings one into the place of the sacred. Sacred is often defined as being set apart. What if every moment could be set apart from the natural life and lived supernaturally? What if holy vision could be seen in every moment? The sacred can be found everywhere if we have eyes to see and ears to hear. Revelation that is holy can be found in a leaf, or a smile, or a sound. Holy revelation can be a dwelling place, not merely an occasional happening. Jesus saw it this way. Bread and fish were not simply things to eat - they were elements for miracles. Fishing nets were not simply tools for a vocation - they were symbols to common fisherman that their lives could be filled up with souls by casting nets of love and power.

Holy revelation can be found wherever God is - and isn't He everywhere? The dinner table, as mentioned earlier, can be a sacred place of holy revelation of the Father's goodness. Story-time around a campfire can become a sacred place of unity among friends. A nature walk, a shopping experience, a conversation with a friend, time spent in the studio, singing in the shower - these all can become sacred spaces. We must simply look at our experiences from a different

perspective, inviting and being aware of God in every moment. The compartmentalization of our lives is a sure deviation from the sacred vision.

Faith

"Faith is the substance of things hoped for - the evidence of things not seen."

Observation of the goodness in our everyday lives builds thankfulness and thankfulness builds expectation and expectation builds hope, which builds faith. - John Milton said, "Gratitude bestows reverence, allowing us to encounter everyday epiphanies, those transcendent moments of awe that change forever how we experience life and the world." Grateful observation is key to living a creative life, but furthermore, it is also key to living a faith-filled life.

When we train the natural eyes to see and the natural ears to hear the beauty that is in our path, it has a way of igniting the heart, opening the spiritual eyes and ears, and causing our spirit to align with Holy Spirit in faith. Holy Spirit is always displaying the divine glory. When the depth of Holy Spirit calls to the depth of our spirit and we observe and respond, we come into unity with the divine and faith is established. It is in the God-moments like these that we truly capture the evidence of the thing that was not previously seen. Creative responses can move

the evidence from the spiritual realm of mere belief into the realm of our reality. It is our calling to live in faith - without faith it is impossible to please God. Is it possible to please Creator without creativity?

Confidence

Faith will produce confidence. The calling of all of humanity is to live creative lives. Many will find it, yet it takes tenacity and an obsession for seeing God's face to sustain a creative life. We must settle for nothing less than the rich beauty of His presence in the continual moments of an eternal creative life. This is worship. This is artful living. This is confident alignment with the Creator.

This type of creative abandonment goes against our fallen nature to live our lives conformed to some lesser structure. It takes courage to live creatively, not trusting the world's religious boxes. It requires sensitivity to the Spirit and confidence that you hear and see His movement. With that understanding, you truly live and move and have your very being in the divine. It looks different than the norm. A sweet boldness is the sign of those who cannot go back to the typical life.

The calling to live a life of creativity is a call to revolution. The primary fight lies between the fallen nature and the awakened creative life. Those awakened to that calling will change the world. We

will shift atmospheres, change cultures, and as we connect with the truth of the kingdom in creative ways, we will see the kingdom come to earth, just as it is in heaven. May we have a creative revelation that will spawn a revolution. It is time for change. The Spirit and the Bride say, "Come, Lord Jesus come."

This is War

Throughout the ages the enemy has, in many ways, successfully ruled the realm of the creative arts. With the world's systems and cooperation, especially in recent decades, every genre of the arts has been brought to some of the lowest levels of perversity imaginable. A common thought in our modern times is that God is dead and art is dead. Neither is true, however, the artistic expression at the forefront of society shows a lifeless or horrid existence.

God's power is not evident in most of Christianity. Sadly, yet for hundreds of reasons, the church has become a joke to many, a hypocritical system of hype, a false sense of hope. There is no power in our teachings and the miraculous rarely exists. When it does come we scrutinize. It is thought by most that Christians do not resemble Christ, much less reflect Him. A demonstration of power - true power - needs to be on display. Creativity is the gentle weapon. There is a revolution forming whose banner is love. Creativity is such a gift and an inheritance. It is time to have a beautiful war.

The war begins with us. I hate to be cliche, but the only way to change the world is to start with ourselves. The enemy wants to depress our expression with the mediocrity of a religious systematic structure. We must be the crazy ones! Color outside the lines! Sing in the grocery store! Write a poem! Take up your arsenal of creative weaponry! The enemy desires to blur your vision with the things you think you must do to achieve a successful life. Ask yourself if your goals are God-ideas that bring a freshness to life. Is your vision coming out of dreaming creative dreams with Holy Spirit? Is your heart open to the deep-unto-deep vision of God? Do you believe in your ability to express the heart of God in creative ways - do you see the connection? The enemy would love to steal your faith and damper your confidence. He loves to cause you to be conformed to the rules of the world. The pharisee could never see anything outside of the rules. Are you bound by the rules of the expected form of society or are you moving with the Spirit?

"What no eye has seen,
 what no ear has heard,
and what no human mind has
conceived"—
 the things God has prepared for those
who love him—
these are the things God has revealed to
us by his Spirit."

The Need

I'd like to bring you into a real-life story from my experience as an artist and a teacher that I believe tenderly, yet powerfully reveals the need we have to connect with God in richly creative and artful ways. The following is a scene from my life in which I learned something of Papa's creative heart for us. In this experience, I had the joy of seeing art provide a safe place for a child in a difficult situation. Art is like that - when held in the right respect, it becomes more than a thing - it becomes a place - a sacred place. We all have a great need for that sacredness in our lives.

> The LORD is my strength and my shield; my heart trusts in him, and I am helped.
> – Psalm 28:7

I sat there in a crowded negative place among people who seemed so different than me, yet, whom I was way too familiar with. I was realizing what a different person I had become in recent years. To put it plainly, I was uncomfortable, I wanted to leave and just get out of there.

Then.... there he was, sitting beside me with his legs swinging back and forth and talking "a-mile-a-minute." If it were not for his wide-eyed wonder, I may have found a way to be distracted from his chattering. He went on and on but then spontan-

eously said, "So, you can draw like real-stuff - how do you do that?" And then his hands went up, as if sculpting the air, and he said, "How do you make it look like it is coming off the page?" I answered him, something typical like, "Well, you just have to practice." Up he came out of his seat and through the screen door he went faster than I could think about what he was doing. I thought, "Well, there he goes, off to something else," but then as quickly as he left, he returned with a stack of paper, pencil, and some of his drawings he had been working on. He said, "Show me." A smile came across my face. This wiry bundle of randomness, typically viewed as a nuisance, or the "one to keep in line" was asking for an art lesson and was being diligent about getting just that.

We sat there for a long time, talking about how drawing was just a matter of seeing, how letting the pencil move under your fingers in connection with your eye causes freedom in drawing, and how capturing reality was a matter of being able to touch the object visually without literally touching it. He got it! As we talked and practiced drawing objects, I quickly saw that I could relate to this usually immature, even what others called *babyish*, child on an amazingly mature level - which was more than I could say for most of the adults loafing around - the source of my previous discomfort. So as we talked and drew, I was astounded at the levels he passed through in his drawing in a matter of about forty-

five minutes. He went from very flat map-like drawing to being able to capture form and line, shadow and highlight, and realistic figure sketching. It was nearly genius - but this was not the most impressive thing about my encounter with him. There was something more gained.

At some point, while my new art protege and I were immersed in these empowering moments of learning a skill that many desire, but few pursue, one of the adults who typically kept this little boy "in-line" decided, for no other reason that I can think of except to be cruel, that he needed to be reminded of the nuisance that had defined him. So, she began by saying she was so surprised that he was sitting that still to learn anything. She indirectly shot off comments that he just thought he was *all that* because he could draw now. He ignored her. My praise towards him increased. She continued. He began to shrink - literally, tucking his shoulders in and ducking his head low. He managed a little insecure chuckle but continued drawing. So she brought out the big guns and said, "Ask him how he's been acting? You should see him when he gets so angry – he throws one more fit on us – scratching his own arms, and yellin', and crying like a little baby." I was just about to come to his defense and strongly explain to her that he probably acted that way because it was the only way he knew to deal with her verbal abuse, which was loudly on display in that very moment, BUT....

I looked at him and he was about to lose it - tears were welling up behind those eyes which had moments before been filled with wonder and confidence and he took about two deep breaths, tightened his shoulders, and he...

DREW.

And as her poisonous chattering seemed to fade off into a tunnel where it could never reach us in that moment or hopefully, in any other moments again - he drew, and drew, and drew.

As I watched his shoulders relax and his confidence stabilize, I knew that God had given him, through our simple art lesson, a very powerful tool to endure the poison of the enemy. The Father had given him, in a sense, a place of worship.

That's what art is about. It's more than art. It's about a life abundant with goodness. Artful living pushes out the darkness of everyday life. We need creativity to provide places of life and light. Creativity is an anti-venom to the enemy's poison.

ABOUT THE AUTHOR
PATTIE ANN HALE

www.PattieAnnHale.com

Pattie Ann Hale is a leader in the contemporary exploration of arts and faith. Besides her daily work as a professional visual artist, she also regularly speaks and teaches at events and artist gatherings and paints live during worship events. The continual sharing of her creative life and wisdom gained by that experience through online platforms such as her Journeyartfully writings, video blog, artistic life-coaching programs, and online classes has given her opportunity to speak into the lives of many experienced and *up-and-coming* artists interested in exploring their faith through the avenue of the arts. She leads seminars and hands-on workshops concerning the spiritual in the arts throughout the country and abroad. In her workshops, which often focus on wholeness and healing, she guides participants in experiencing a spiritual visual language.

Pattie Ann Hale is the author of Sacred Revolution – The Power of God in the Arts and co-author of Unlocking the Heart of the Artist Experience Guide with Matt Tommey. She is the Associate Director of The Worship Studio (www.theworshipstudio.org), an international ministry focused on the arts and faith. She is the former director of the MorningStar Art Gallery of MorningStar Ministries and Publications (Charlotte, NC)

where she was on staff as a layout artist and was an integral part of the MorningStar Worship Art Team from 2007 – 2009. Pattie is the former director of The Appalachian Arts Center, which is a retail gallery and educational and community art center that focuses on local artists and the arts of the Appalachian Mountains.

Pattie Ann Hale, a native of the Appalachian Mountains of Southwest Virginia, works daily in her professional studio and gallery in the River Arts District of Asheville, NC. She is a visual artist, writer, and teacher who focuses on the connection to the sacred through art. Her spiritual expression is primarily carried out through oils and acrylics on canvas. As she creates intuitively through a process of movement, prayer and play, her art mysteriously unfolds from a place of journeying in the spirit and the visual story comes into surprising existence. The resulting paintings are expressive offerings of metaphorical images, abstraction, and a reflection of movement. Her layers of color and perspective create depth and dimension which invites one to see beyond the natural and into the place of the spirit. Her art is inspirational, contemplative and provoking.

In her formative years, Pattie Ann Hale studied intensively with and was mentored by artist Ellen Elmes, from the New York area, who was a Parson's School of Design student, and who was an arts and cultural advocate to the Appalachian Mtns. Ellen's philosophy of, "Art is a language that allows us to share and communicate the essence of being human," greatly influenced Pattie Ann's art and process of study. Throughout her career, since her college art studies with Elmes and other inspiring teachers, Pattie Ann has been on a studious journey of art history, creative marketing seminars and

workshops, many spiritual worship conferences and schools, technique workshops by various facilitators, intense experimentation, art gatherings to study and share technique and philosophy, and traveling to see some of the finest art in New York City and Washington DC, as well as taking every opportunity to see and study fine art in smaller cities such as Atlanta, GA, Charlotte, NC and her own amazing culturally rich artistic area of Asheville, NC. Pattie's work is collected throughout the nation and abroad by private and corporate collectors. Her work is represented in the Art and Faith Catalog by White Stone Gallery of Philadelphia, PA, The Barr Gallery in Abingdon, VA, Red Poppy Studios and Gallery in Layfayette, IN, and at Cairn University via White Stone Gallery, Philadelphia, PA.

As an artist, writer and teacher, Pattie Ann's focus is to help people come closer to God, to develop a relationship with Him, and to step into fresh revelation in the Spirit. Believing everyone is an artist, her workshops and seminars, teachings and books help people to unlock the true artist within – to build an avenue for expression – to develop one's own visual conversation with God.

Made in the USA
Lexington, KY
11 March 2015